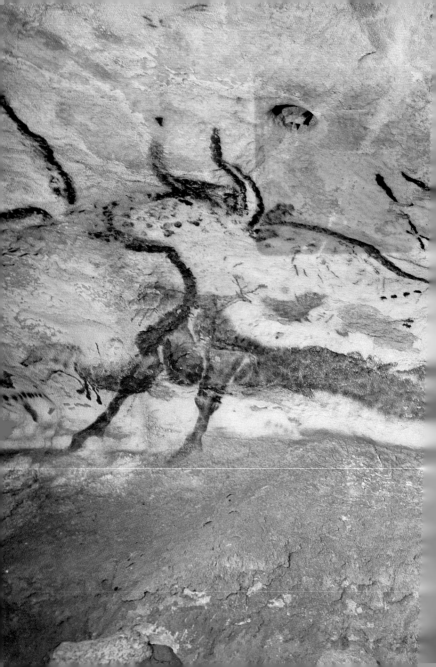

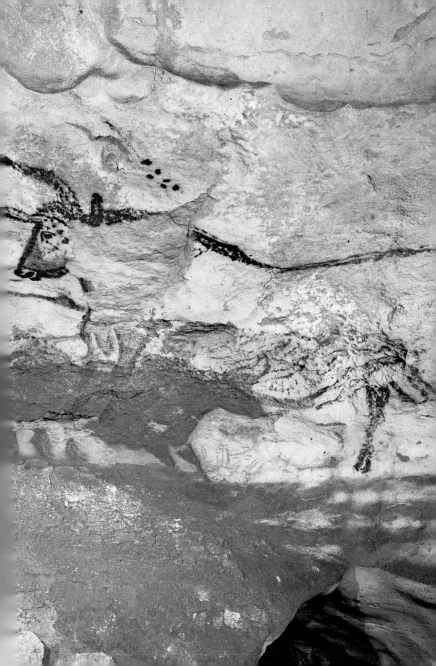

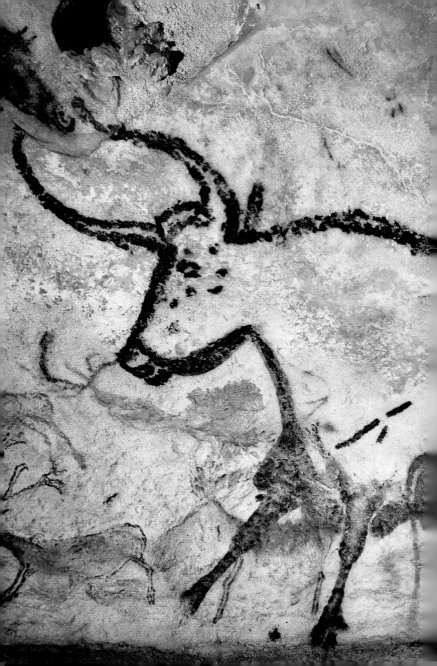

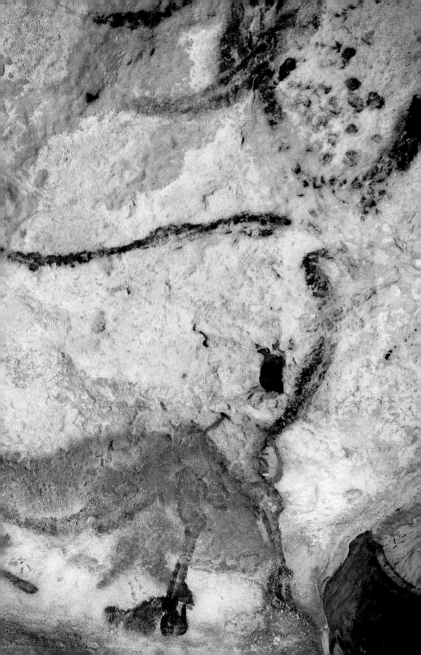

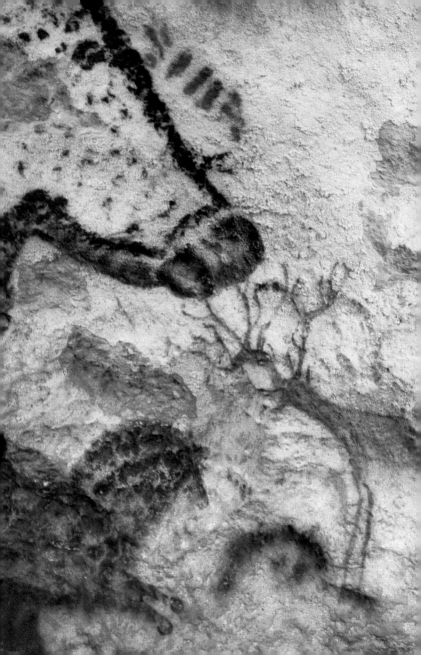

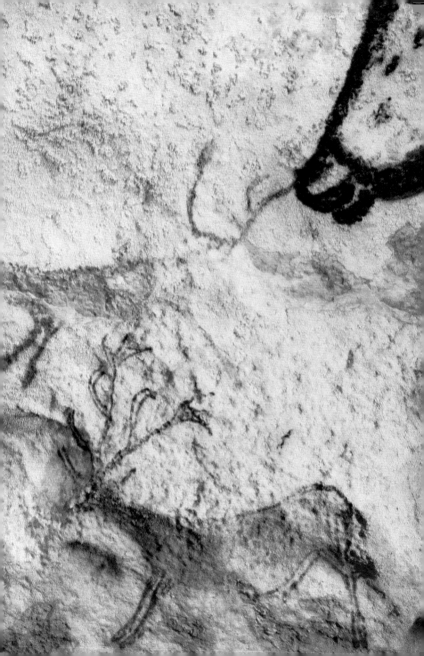

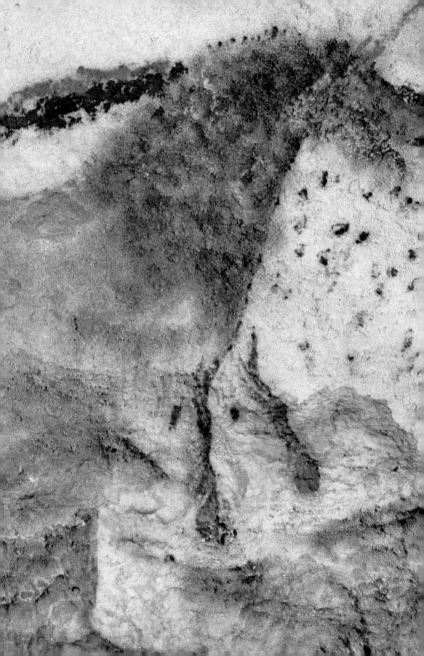

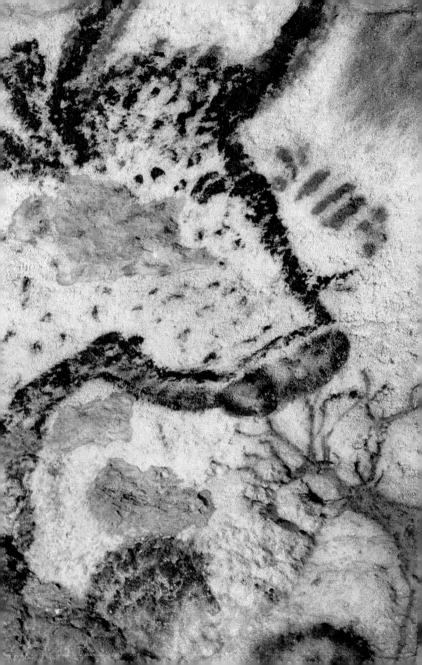

CONTENTS

PREHISTORIC ART
AND CIVILIZATION

Denis Vialou

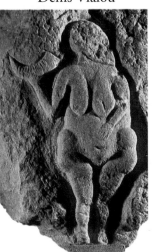

DISCOVERIES®
HARRY N. ABRAMS, INC., PUBLISHERS

Mental activity was decisive in separating humans from other primates. By using their brains, humans made tools. *Homo sapiens sapiens* had a revolutionary impact on people and society.

CHAPTER 1

'HOMO SAPIENS SAPIENS', MODERN HUMANS

Whether a rock wall transformed into a grotesque mask through the magic of black lines (cave of Altamira in Spain, opposite) or an animal carved on a perforated baton made of reindeer antler (cave of Le Mas-d'Azil in the Pyrenees, right), Palaeolithic art displays the modernity of thought of the great hunters from Europe during the last glaciation.

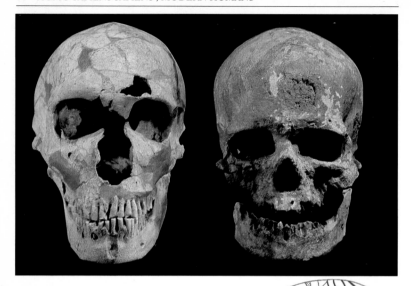

The cerebral tool

Formed in the passage of time by the progress made in technology and in behaviour, the human brain has evolved – its anatomy, its functions and its physiology have altered as a result of the increase in its size. The study of the meningeal networks, whose imprint remains visible on the walls of fossil crania found in prehistoric sites, confirms the evolutionary changes to the skull as revealed by palaeoanthropology (the branch of anthropology concerned with primitive humans). It shows their increasing complexity, related to the constant growth of the brain in the whole of its motor and associative areas, including the frontal lobe, which was the last to develop.

With *Homo sapiens sapiens*, the unlocking of the brain's frontal areas was finally completed by barely forty thousand years ago. It was a determining factor in the relatively sudden and rapid explosion of symbolic activities, in particular of so-called artistic manifestations. With the acquisition of new mental

The skulls of a Neanderthal (above left) and of a Cro-Magnon (above right) show the evolution of the two representatives of the species *Homo sapiens* in Europe. Cro-Magnon has the high face of *Homo sapiens sapiens* with its vertical forehead, rectangular eye sockets, a pronounced chin – modern features that are absent in Neanderthals.

capacities, humans found themselves in possession of numerous technical and social powers that increased tenfold their ability to control their world.

From *Homo habilis* to *Homo sapiens*: 2,500,000 years of technological evolution

The well-preserved tools of stone – flint, quartzite and quartz – starting with the toolkits invented by *Homo*

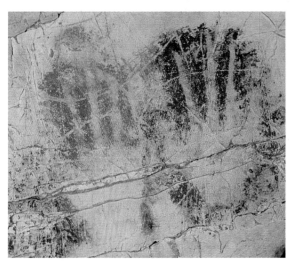

habilis 2,500,000 years ago, allows lithic industries to be compared and to be classified according to their chronology. For prehistorians, the first identifiable stone tools are those whose forms stem from a series of repetitive gestures. These are the worked pebbles or *choppers* and *chopping tools*: pebbles presenting, at one of their ends, a cutting edge obtained by organized removals of flakes. This first period of worked-pebble industries, which unfolded in Africa over a million and a half years, was followed by the

Knowledge of the physical attributes of prehistoric people comes from occasional finds of precious and fragile archaeological evidence, such as these painted hand stencils (left, in the cave of Roucadour in France). The imprints of hands and feet, and sometimes of knees and elbows, preserved in the clay of caves are even more interesting from the anatomical viewpoint. Some children played at pushing their fingers into the soft cave floors, and some of these hands show evidence of bitten fingernails.... As for endocranial casts, they reproduce the natural imprint of the brain on the internal wall of the skull and enable the meningeal vascular system to be studied – anatomist Roger Saban has shown its evolution from the australopithecines (the early primitive hominids) to *Sapiens*. It can be seen in the increasing complexity of the meningeal network. The endocranial cast of the La Quina Neanderthal, dating to about fifty thousand years ago, shows modern characteristics in the high number of anastomoses that form a fairly dense vascular grid, especially in the left hemisphere (left).

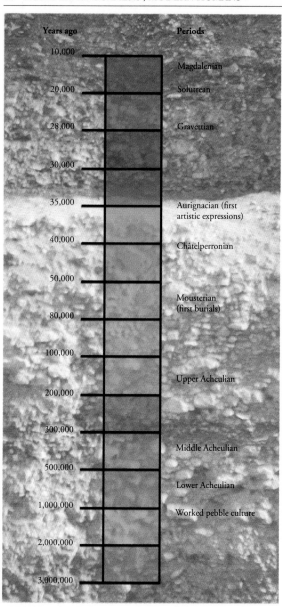

Years ago	Periods
10,000	Magdalenian
20,000	Solutrean
28,000	Gravettian
30,000	
35,000	Aurignacian (first artistic expressions)
40,000	Châtelperronian
50,000	
80,000	Mousterian (first burials)
100,000	
200,000	Upper Acheulian
300,000	
500,000	Middle Acheulian
1,000,000	Lower Acheulian
2,000,000	Worked pebble culture
3,000,000	

The Palaeolithic of the Old World begins about 2.5 million years ago with the first known tools, and ends 10,000 years ago. It is divided into three periods: the Lower Palaeolithic (from 2.5 million to about 200–150,000 years ago), the Middle Palaeolithic (200,000 to 35,000 years ago) and the Upper Palaeolithic (around 35,000 to 10,000 years ago). Each period has cultures characterized by their tool industries. They take their names from the excavated sites where they were first found: for example, Mousterian from Le Moustier in the Dordogne, or Solutrean from Solutré in Saône-et-Loire in France. The Upper Palaeolithic, featuring *Homo sapiens sapiens*, comprises several cultures: the Aurignacian (35,000 to 25,000 years ago), the Gravettian (28,000 to 22,000), the Solutrean (22,000 to 18,000), the Magdalenian (18,000 to 10,000). This general sequence does not reflect a linear reality: the cultures often overlap in time and sometimes coexist in the same geographical area.

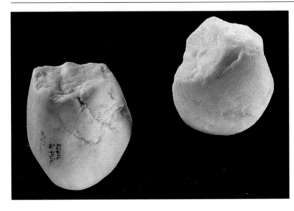

Stone tools are the best preserved remnants of prehistoric material cultures, known as 'industries'. Some tools are found over long periods, and are widely distributed over immense areas. Worked pebbles (left) characterize the first industries of the Lower Palaeolithic, followed by the handaxes of the Acheulian industries (below) for hundreds of thousands of years in Africa and Eurasia.

Acheulian cultures of *Homo erectus* in Africa, and in Europe and Asia. The all-purpose tool, present in most of their industries, is the handaxe: a block of stone, worked on both sides to obtain the maximum peripheral cutting edge, with a point at one end and the other left rounded for a good grip. Cleavers, tools with a tapered cutting edge that is perpendicular to their long axis, and flake-tools such as sidescrapers and denticulates, are sometimes abundant in certain Acheulian assemblages; they show the progressive enrichment of the lithic industries of the Lower Palaeolithic.

Between the Abbevillian handaxes, which are large with an irregular and sinuous cutting edge, and the fine, perfectly symmetrical bifaces of the Upper Acheulian, 700 to 800,000 years of technological evolution elapsed; the method of knapping flakes and points of desired shapes and sizes also bears witness to the high degree of mastery of stoneworking that was achieved by the evolved Acheulians. *Homo erectus* also progressively controlled fire, around 400,000 years ago in China, in Europe and probably elsewhere. All these innovations represent human beings' mental and social development, of which the stones and the habitation floors have preserved lasting traces.

From the Middle Palaeolithic to the Upper Palaeolithic, the refinement of a toolkit

The range of the tools of *Homo sapiens* during the Middle Palaeolithic in the Old World – especially in the eastern periphery of the Mediterranean – is clearly more diversified than in the Lower Palaeolithic: there are four or five times more types. The worked tools and weapons, like handaxes and cleavers, become more refined and present cutting edges that are longer and more regular than before. The tools made from flakes, and sometimes from blades, multiply, with new or more developed forms, adapted to new practical functions and to hunting and the butchery of game. Numerous industries, differentiated by regions and cultures, flow from the accumulated inventions of new tools.

The great Mousterian culture that came after the Acheulian between 200,000 and 100,000 years ago, in Europe, Asia and Africa, is far from homogeneous, with technical and cultural diversification over sometimes relatively small regions. Endscrapers, burins and awls on blades now become common. The systematic production of blades and bladelets, instead of flakes of no particular or predetermined form, is due to the rational organization of the knapping of blocks of raw material, carefully chosen and then prepared for

In contrast to the more or less universal stone tools, there are tools and weapons, sometimes even techniques, that are exclusive to certain cultures: Mousterian points (far left) are sufficient to designate the assemblages that contain them as Mousterian, just as shouldered points (left) characterize the Upper Solutrean. The scaly retouch that gives the edges of a Mousterian point their definitive shape is the result of a rapid (a few tenths of a second) series of simple, orderly movements. The flat, parallel, invasive, regular retouch that completely shapes the upper face of a shouldered point is produced by advanced technology. The use of a soft retoucher (antler, bone or wood) applying pressure to the sharp edges of the initial blade support makes it possible to shape the point, and takes many minutes.

this purpose by a series of precise gestures. Many of the industries created by *Homo sapiens sapiens* benefited from this considerable technical progress that enabled them to obtain, from the same quantity of raw material, a greater number of elongated blanks, their sizes calculated according to the anticipated tool shapes and intended functions.

In the Upper Palaeolithic, the edge of a blade or bladelet was systematically worked by using a continuous, direct, inverse or alternating abrupt action to produce a back that, like that of a knifeblade, reinforces the strength of the support, and allows it to be sharpened as much as possible. On bladelets that had been retouched in this way, the backs lend themselves to being fixed to grooved shafts of reindeer antler, with just the cutting edge emerging from the shaft to ensure that the weapon penetrates deep into the prey. Points, often shouldered or stemmed to facilitate hafting, become the ideal hunting weapons. The Solutrean shouldered points were carefully worked and retouched so as to be perfectly balanced, and have extremely fine tips of under a millimetre – their effectiveness depended on the mastery of all these different factors to do with their form and shape.

Homo sapiens sapiens, an ingenious architect

Huts of prehistoric hunters have been reconstructed – after careful examination of the remains found during excavations – by using pieces of wood from the very

The organized knapping of large cores in order to obtain blades systematically meant that the Magdalenians of Pincevent (Seine-et-Marne in France) had to carry out a minute preparation of the cores, followed by an irreversible series of actions aimed at detaching each blade (above).

earliest periods (almost a million years for the camp of Lavaud in the Indre region of France, for example). There are chocking stones, and occasionally post-holes, which, after the timbers they contained have rotted, became filled with sediment; they are easily detectable in section, and enable the dwelling's ground plan to be drawn. By a simple process of evaluating the architectural constraints, the framework can be erected with the materials available at the time – wood, branches, and, as a covering, branches, foliage or skins, as in the camp of the Magdalenian hunters of Pincevent (Seine-et-Marne), which was located near a ford on the Seine.

The inventive and ingenious mind of *Homo sapiens sapiens* is particularly revealed in the rational use made of materials from hunted animals. The ability to work wood, to cut it up, and make various tools with it helped to refine the expertise in working ivory, bones and antlers. Deer antlers, especially those of reindeer and red deer whose numbers depended on the place and the climate, must have often been used for making the covers and walls of huts rigid,

The in-depth analysis of habitation floors, of the distribution of objects, and of areas with no trace of activities requires excavations that peel off large surfaces, as at Pincevent. In the course of this operation, all archaeological objects uncovered, be they tiny bone flakes or lithic debris, are left in place until the end of the spatial analysis. The detailed observation of remains left by organic materials is also indispensable. The quality of any reconstruction depends on the quality of the excavation. A distinction can then be drawn between Magdalenian huts from the site of Pincevent (left) or those from Gönnersdorf (opposite).

as studies of Palaeolithic dwellings show. The size, suppleness and elasticity of antlers were features not found in bones. Being less hard, antlers are easier to work, and Palaeolithic people were able to alter their natural curvature by using heat to straighten the rods that they extracted from them in an at times sophisticated and very effective way. Mammoth tusks,

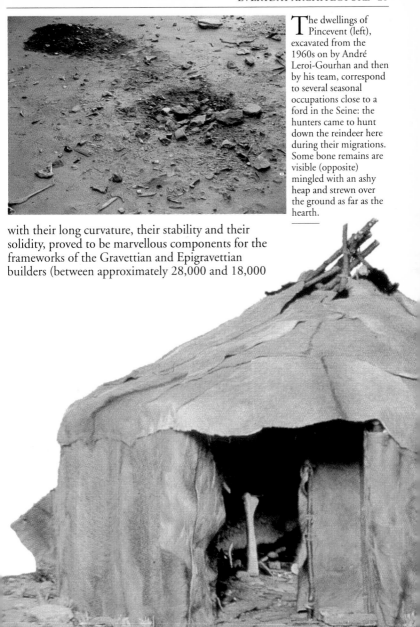

The dwellings of Pincevent (left), excavated from the 1960s on by André Leroi-Gourhan and then by his team, correspond to several seasonal occupations close to a ford in the Seine: the hunters came to hunt down the reindeer here during their migrations. Some bone remains are visible (opposite) mingled with an ashy heap and strewn over the ground as far as the hearth.

with their long curvature, their stability and their solidity, proved to be marvellous components for the frameworks of the Gravettian and Epigravettian builders (between approximately 28,000 and 18,000

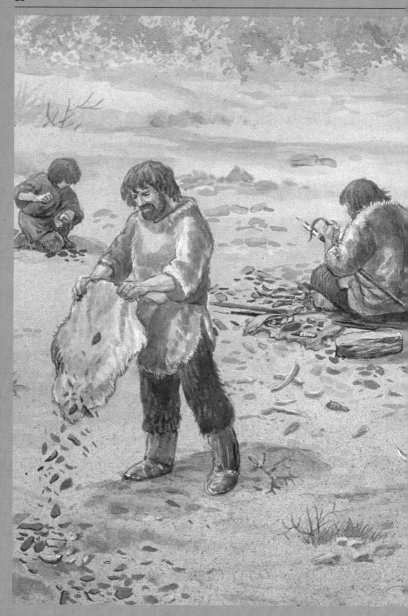

This illustration of the site of Pincevent is not at all far-fetched, but is based on the results of scientific observations. The vegetation can be reconstructed thanks to the study of pollen and sedimentology, while the animal remains provide information about diet, clothing and architectural practices. In order to illustrate the activities of these prehistoric people, the artist drew inspiration from the technological remains and from information from experiments, for example in the knapping of flint flakes.

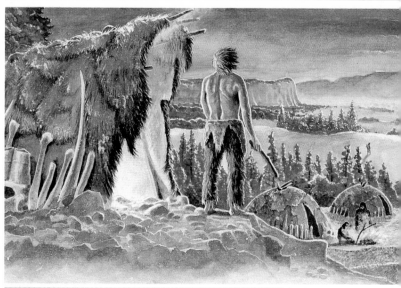

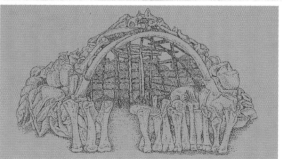

The 'horizontal' excavations over large areas, carried out in eastern Europe (Ukraine, Czech Republic, Russia) brought to light the architectural complexity of Palaeolithic dwellings, dating to between 30,000 and 20,000 years ago for the most part. The huts, semi-subterranean (above) to provide better resistance to the wind and the cold, were made up of mammoth tusks. Their piled-up jaws and a fence of long-bones wedged them in place and supported the hides. The dwellings' interior spaces were divided into several cells for the families of the same lineage.

years ago) of the great steppes of eastern Europe and Asia, which were swept by the glacial winds. The tusks were wedged into mammoth skulls, half-buried in the loess soil and were blocked by a fence of the animal's long-bones; they formed a high, streamlined roof, probably hermetically sealed with skins held fast to the framework by stones and mammoth jaws. These admirably well-built dwellings were big enough – up to 35 metres (115 feet) long and 18 metres (60 feet) wide at Kostenki in Russia – to shelter several 'families'

Apart from numerous remains of domestic activities, prehistorians have uncovered in the huts of Central Europe not only ivory ornaments, beads, bracelets, richly decorated diadems, weapons and tools that were decorated, but also, most interestingly, animal and human statuettes in ivory and stone. Female figurines had been buried in pits dug at the edge of the habitation areas. Even more exceptional are mammoth bones, painted with complex geometric red motifs, found inside huts at Mezhirich in Ukraine (opposite). The richness of the Palaeolithic hunters' dwellings reveals the complexity of their societies.

simultaneously, as shown by the hearths found in excavations, as well as the abundant archaeological material, well preserved under favourable conditions. The distribution of these structures on the ground reveals the normal domestic activities: preparing and cooking food, cleaning the floor, maintaining the sleeping area....

The world's first artisans

Mammoth ivory was a noble material for the hunters who could get hold of it, when this powerful animal roamed through their landscapes and perhaps their imagination as well, as their figurines and wall paintings reveal. The jewelry of the Aurignacian (from Aurignac in Haute-Garonne, France), found in numerous habitations from the east to the west of Europe, includes great quantities of ivory beads. Some (at the Blanchard shelter in the Dordogne, for example) were obtained in series through a special technique of cutting up a rod extracted from the ivory, and then perforating them; the technique enabled the size to be gauged precisely. Later Gravettian ivory jewelry is no less exceptional in its finesse and technical prowess, especially in the skilful hands of the Pavlovians of Moravia or the Kostenkians (the Gravettians of eastern Europe) of Russia and Ukraine: rings of no more than a millimetre in thickness, diadems decorated with incised motifs, bracelets carved from the tusk to preserve their natural curvature.

The teeth of deer – especially the canines of reindeer and red deer stags – and of bovids and equids, and especially of carnivores – the canines of felines, bears, wolves, foxes – were very often perforated, strung and worn as pendants or necklaces by the living and by the dead in their graves.

Bones, thick or thin, long or broad, were used in abundance to produce a fine display of tools, implements and objects. From reindeer shoulder blades, the Magdalenians of the Pyrenees and Aquitaine cut out discs, then perforated them (perhaps to be worn as

The teeth of hunted animals were frequently used by prehistoric people for making some of their ornaments, especially pendants. The perforation was generally made in the softer root, especially in carnivore canines. The presence of fangs of dangerous animals (left), probably hunted for their skins and not for consumption, was important in the symbol system of the bodily ornaments of the living as well as the dead who were buried with them. However, the parietal (cave) and portable art (statuettes, tools, weapons) accord little importance to carnivores, although the bestiary, essentially comprising herbivores, does not reflect the fauna that was actually hunted. Yet the bone discs that the Magdalenians cut out of reindeer shoulder blades (opposite top), and then perforated, are decorated with animal figures and geometric motifs that are comparable with the portable art.

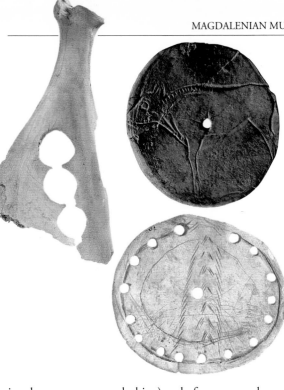

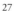

Traces of percussion on mammoth shoulder blades in eastern Europe, on draperies and concretions in decorated caves in western Europe, as well as lures and a few flutes carved in cylindrical bone tubes, provide evidence of musical practices in the Magdalenian. Replicas of these instruments, tested in decorated caves, have enabled Magdalenian sounds to be reproduced. Below: a Magdalenian flute.

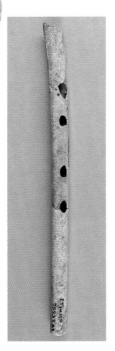

jewelry or sewn on to clothing) and often engraved them with abstract, geometric or figurative motifs. Ribs of herbivores were often transformed into smoothers, knives, or scoops, through simple abrasion of their edges or sharpening of their ends. Daggers and handles were carved in the diaphyses of long and tough bones, flutes and lures in hollow and cylindrical bird bones.

The rite of the hunter

The immense herds of reindeer that were found throughout Europe except for its southern peninsula during almost the whole of the Upper Palaeolithic provided the hunters with an inexhaustible and easily accessible living supply of meat and of materials with which to make tools, weapons and small ornamental pieces. The exploitation of the antlers – from both males and females – revolutionized hunting techniques and brought about a profound change in societies, in

their organization and their
population growth.

The spearpoints made of the
rods extracted from antlers vary greatly during the
Upper Palaeolithic, not only in style but also in
technical solutions. Some are flat, others have a
cylindrical or oval cross-section. There are
lozenge-shaped spearpoints, others with a simple or
double bevelled base, or with a short or elongated split-
base: there are as many variations as there are possible
hafting methods, and thus as many practical
adaptations to the constraints of the materials chosen
for the shafts and the ballistic demands of the
projectiles.

The manufacture
of weapons, the
continual refining of
hafting methods for
projectiles and stone
barbs on well-balanced
shafts enabled the Cro-
Magnons to develop
hunting techniques that
increasingly favoured
settlement and
population growth.

Moreover, the Magdalenians invented a particular system of manufacturing spearpoints that avoided the natural curvature of the rod extracted from the antler: instead of carving a more or less flat or cylindrical shaft, they made two half-cylinders, which were fastened together to form a perfectly straight shaft through gluing and binding. The very sharp spearpoint, solidly hafted, and thrown at the game or stuck like a lance into the hunted animal, proved itself a formidable weapon, and one that was easy to re-use or to replace when – a frequent occurrence – it broke. It is known that the addition of lateral barbs (backed bladelets) stuck into grooves cut for them made it even more lethal.

Two revolutionary inventions: the spearthrower and the harpoon

Invented by the last Solutreans, but mostly developed and used by the Magdalenians, the spearthrower represents a decisive advance for the techniques of hunting big game with projectiles. With this tool, the Magdalenian hunters perfected hunting at a distance, obviously a more efficient method than the always uncertain and perilous one of approaching to within striking distance of herbivores and carnivores, which are quick to flee or threaten. Normally cut from antlers of reindeer (or red deer), and sometimes from bones (and probably wood as well), the spearthrower is a lever, with a cut-out hook at one end, or with a hollowed-out groove to wedge the base of the weapon to be thrown. Studies of Aboriginal or Eskimo hunters,

The Reindeer Age, a term used at the end of the 19th century for what is now known as the Magdalenian, shows the economic role played by this animal. Reindeer provided an abundance of flesh for consumption. Their bones were made into tools and weapons, and also served as supports for engraved or carved depictions. Antlers, skins and tendons were used for clothing and for hut coverings.

Opposite above: Upper Palaeolithic spearpoints made from reindeer antler. Opposite: a perforated baton used as a shaft straightener.

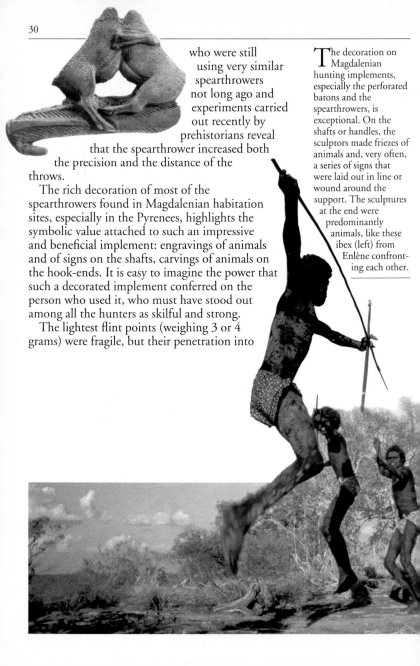

who were still using very similar spearthrowers not long ago and experiments carried out recently by prehistorians reveal that the spearthrower increased both the precision and the distance of the throws.

The rich decoration of most of the spearthrowers found in Magdalenian habitation sites, especially in the Pyrenees, highlights the symbolic value attached to such an impressive and beneficial implement: engravings of animals and of signs on the shafts, carvings of animals on the hook-ends. It is easy to imagine the power that such a decorated implement conferred on the person who used it, who must have stood out among all the hunters as skilful and strong.

The lightest flint points (weighing 3 or 4 grams) were fragile, but their penetration into

The decoration on Magdalenian hunting implements, especially the perforated batons and the spearthrowers, is exceptional. On the shafts or handles, the sculptors made friezes of animals and, very often, a series of signs that were laid out in line or wound around the support. The sculptures at the end were predominantly animals, like these ibex (left) from Enlène confronting each other.

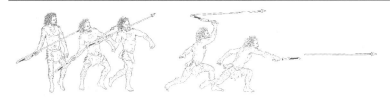

thick hides was unmatched. They were hafted on to the tips of spearpoint shafts carved from deer antlers or, sometimes, the ivory of mammoth tusks. Could they have served as arrowheads? No evidence has ever been provided to prove this suggestion; neither bows, neither tapered shafts nor depictions of hunting with a bow have ever been found in Palaeolithic sites or caves, like those known in painted or engraved shelters during more recent (postglacial) periods in various regions of the world, for example in Levantine Spain. In Europe, during the Holocene, the bow clearly takes over from the spearthrower for the more difficult task of hunting less gregarious animals, or those living alone in an increasingly densely forested landscape. With its greater force and precision, the bow perfects the principle of

The ethnographic comparisons on which the prehistorians of the late 19th and early 20th century relied suffered from a fundamental error: they attempted to compare prehistoric humans with modern people living in natural self-sufficient economies, as if there had been no evolution! What they should have done was to compare only a part of the techniques and objects, such as hunting with spearthrowers by the Australian Aborigines (below), already practised by the Magdalenians (drawing above). In fact, ethnographic comparisons highlight the extremely diverse technological and cultural solutions that people have discovered for solving the problems in their societies and ways of life.

propulsion that was invented about ten thousand years earlier by the Magdalenian hunters in the great open spaces of the glacial vistas.

Harpoons, carved from the antlers of reindeer and red deer (the latter being flatter), represent the final revolutionary invention of the Magdalenians, at the end of the Ice Age, for hunting and fishing quite large species, such as salmon and trout, which must have been widely consumed, to judge by their remains in domestic sites.

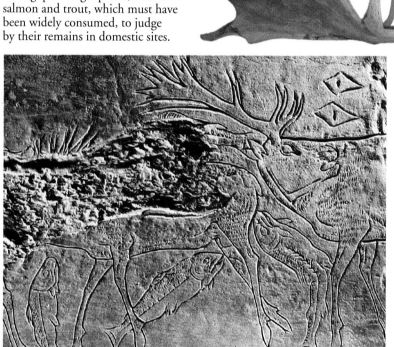

Harpoons were fixed on to shafts with barbs at one side or both, and often perforated at the base (so that a line could easily be attached). These weapons could pierce the animal's flesh and would remain inside the prey.

The realism of the animals contrasts with the abstraction of the lozenge signs on this Magdalenian antler.

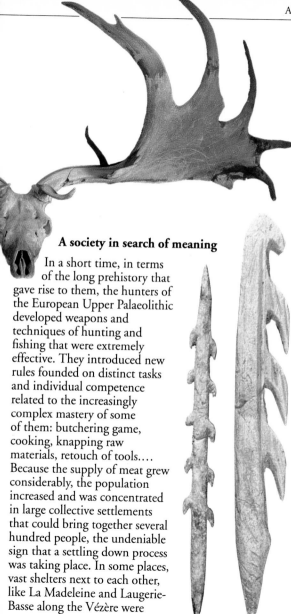

The giant deer (megaloceros) with their enormous antlers (left) were not common in the landscapes travelled by the hunters of the Upper Palaeolithic. Tools and weapons were made from other deer, such as reindeer and red deer, which lived in temperate areas.

It was the Magdalenians who invented harpoons during the last millennia of the late Ice Age. Carved in reindeer antler, their harpoons (left, from Laugerie-Basse in the Dordogne) had a fairly cylindrical shaft. Their barbs, and the frequent perforation at the base for the attachment of a line, made them efficient at hunting and fishing in aquatic environments. The Azilians, who succeeded the Magdalenians in Cantabrian Spain and in France, carved their harpoons in red deer antler, as the reindeer had disappeared from these countries with the end of the glacial climate.

A society in search of meaning

In a short time, in terms of the long prehistory that gave rise to them, the hunters of the European Upper Palaeolithic developed weapons and techniques of hunting and fishing that were extremely effective. They introduced new rules founded on distinct tasks and individual competence related to the increasingly complex mastery of some of them: butchering game, cooking, knapping raw materials, retouch of tools.... Because the supply of meat grew considerably, the population increased and was concentrated in large collective settlements that could bring together several hundred people, the undeniable sign that a settling down process was taking place. In some places, vast shelters next to each other, like La Madeleine and Laugerie-Basse along the Vézère were

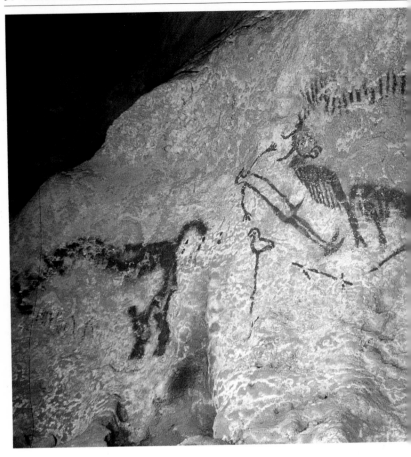

densely populated at the end of the Magdalenian; in others, such as the agglomerate settlements on the Russian plain, semi-subterranean huts were occupied by Gravettian mammoth-hunters.

Instead of practising the opportunistic scavenging that had characterized human prehistory for a long time or experiencing the hazards of hunting that *Homo erectus* and the Neanderthals had come across, Upper Palaeolithic people became organized and experienced hunters. Their new techniques radically changed their

At Lascaux, there is only a single depiction of a human, a bird and a rhinoceros.

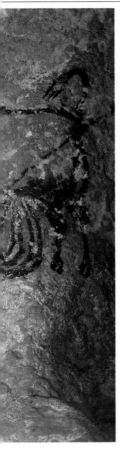

relationship with the natural environment. As territories were more intensively exploited, so landscapes altered and plant and animal resources were more carefully managed. Archaeozoology provides clear evidence of these changes, based on the choice of hunted animals according to their age and sex. The animal bones found by excavations in cooking areas or butchery zones, the positioning of sites on a ford or on a migration route, at the exit from a pass or at the edge of a narrow valley, which was therefore easy to monitor, highlight this selective behaviour, thanks to which the stock of game was maintained and its renewal ensured.

The intensification of hunting, which gradually became more efficient, resulted in population growth, which, in turn, led to a more settled way of life. The domestication of plants and animals in several parts of the world 4500 years ago, and sometimes even more, was the first great conquest of a technique of production by certain Neolithic peoples.

The Upper Palaeolithic hunters probably did not try to evoke the scenes of daily life in their art, as imagined by the Czech illustrator Zdénék Burian (above). On the cave walls or the shafts of hunting weapons, animals and humans are found together, though they are not linked; they simply coexist. The 'shaft scene' at Lascaux (left) was for a long time interpreted as an illustration of hunting; but it is nothing of the kind. The scene seems more imaginary than realistic.

From Africa, more than a million years ago, *Homo erectus* spread to Europe and Asia up to the far end of Indonesia, which was then a peninsula. However, these humans were not able to go as far as some immense territories that were beyond their technological reach and protected by natural barriers. Within fifty thousand years, *Homo sapiens sapiens*, modern humans, completed the conquest of the world.

CHAPTER 2

'HOMO SAPIENS SAPIENS', THE CONQUERORS

Between 50,000 and 10,000 years ago modern humans spread throughout the world. Today their descendants are adapted to the most extreme conditions, proving how successful humans have been in becoming independent from Nature.

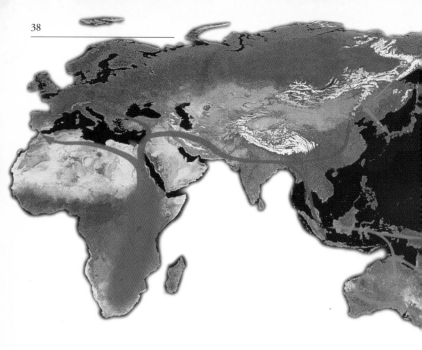

Spreading throughout the globe

When it was colonized, present-day Australia was joined to New Guinea in the north and Tasmania to the south. This 'great Australia' was separated from the Asiatic peninsula of Sunda – nowadays fragmented into a string of islands by the last rise in sea level at the end of the Pleistocene – by an arm of the sea, about a hundred kilometres (sixty miles) wide. This strait could only be crossed on craft manned by daring *Sapiens*, the first known navigators, at least forty thousand years ago.

Beringia, a natural bridge that emerged during the marine regressions of the Quaternary, was a thousand kilometres (about six hundred miles) wide from north to south, and opened the way into the American continent for those *Sapiens* who were capable of dominating the extremely severe climates of the tundra and steppes that were blocked to the east by the high

The conquest of the world began more than two million years ago with *Homo habilis*, whose migrations in Africa are only partially understood. It ended recently – in historical times – in the Pacific islands. It is possible that *Homo habilis* left Africa, but there is no proof of this. However, *Homo erectus* certainly did travel further afield, because their tools and skeletal remains are scattered throughout Europe and Asia, from at least 1.5 million years ago. The last conquerors were *Sapiens*, either from a homeland in the eastern Mediterranean

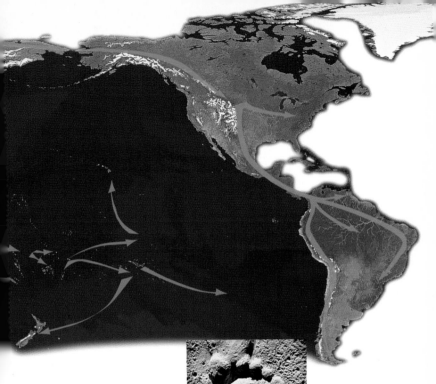

chain of Brooks and the
Rockies. These mountains
were then beneath the thick
icy covering of the *inlandsis*,
which was at its maximum
extent during these very cold
phases, with sea levels
consequently much lower
than today.

The successful economic
adaptation of the hunters of
mammoths, horses and bison in Beringia, Alaska and
Canada (site of Old Crow, Bluefish Caves) was followed
by a second phase of migration to the east, when a
passage opened up between the Rockies and the
retreating ice sheet covering the Canadian Shield.
At the same time, to the west, the rising waters re-
opened the strait between the continents, behind the

and north-east Africa, or
from several populations
derived from *Homo
erectus. Sapiens*
conquered Australia and
America, east of their
place of origin, and
gradually crossed seas
and oceans. Left:
footprint in the cave
of Fontanet, Ariège,
in France.

Satellite view of the
earth above: the red
route shows where
Homo erectus spread;
the green route where
Homo sapiens spread.

first conquerors of the New World, who were then faced with different economic demands on the Great Plains and as far as the extreme south of this immense continent, which was reached at least twelve thousand years ago. The hunters had to adapt to very different environments, such as the high altitudes of the Andes or the irrigated basin of the Amazon.

The spectacular colonization of Australia and America, like that of mountains as they were gradually liberated from their glaciers, and of islands that were progressively reached by steered navigation from the end of the Ice Age onward, reveal the extraordinary ability of modern humans to adapt and the speed with which they were able to resolve the problems posed by the discovery of unknown plants and animals: taro, maize, llamas....

This diaspora of the modern *Sapiens* played a decisive role in the genetic make-up of present-day humankind, of the only human species still alive today: *Homo sapiens sapiens*. These members show great variety and extraordinary cultural

The *Sapiens* species ranges from the hunter of Skhul Cave (below) at Mount Carmel, Israel, to the mythical hunter Manuyu in the sacred Aboriginal art of Arnhem Land, Australia (left).
———

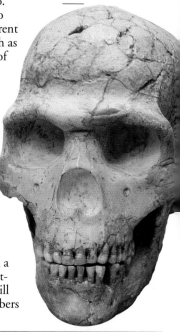

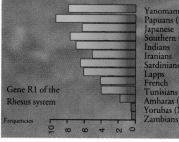

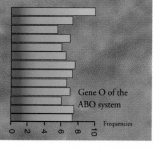

Yanomama (Venezuela)
Papuans (New Guinea)
Japanese
Southern Chinese
Indians
Iranians
Sardinians
Lapps
French
Tunisians
Amharas (Ethiopia)
Yorubas (Nigeria)
Zambians

Gene R1 of the Rhesus system

Gene O of the ABO system

Frequencies

10 8 6 4 2 0

0 2 4 6 8 10

Frequencies

diversity, reflected in the fact that, forty thousand years later, 3000 languages are spoken in the world.

Neanderthal, the European, and Cro-Magnon, the immigrant

The modern prehistory of Europe reflects the importance of *Homo sapiens sapiens*, the conqueror who came from the East to invade lands that were still sparsely and unevenly populated by *Homo erectus* over a million years earlier and for more than 200,000 years by the Preneanderthals and then the Neanderthals (*Homo sapiens neanderthalensis*, who evolved in Europe for several tens of thousands of years, away from the other evolving lineages of *Homo sapiens*). The origins of *Homo sapiens sapiens*, the first modern humans, better known by the name of Cro-Magnon in Europe, are located in the Near East among the early Mousterians discovered in Palestine, especially at Mount Carmel. Traces of Cro-Magnons have been found around 40,000 years ago in central Europe in the form of lithic and bone industries. The culture of the Cro-Magnon people is associated with the early Aurignacian tradition, dating to between 40,000 and 35,000 years ago.

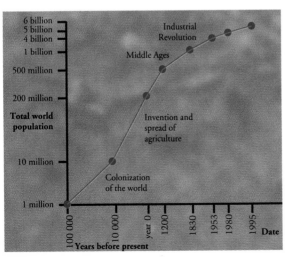

Research into the genetics of populations highlights the anthropological unity of present-day peoples and their relative genetic diversity. The graphs below and opposite were produced by Professor André Langaney and his team of anthropologists. They show that 'in certain cases, there are large differences in gene frequencies, but the same gene can exist in very different populations (for example, gene R1). In other cases, frequencies are practically equal in all populations (for example, gene 0)'. This constant presence of the same genes in the whole population proves that the concept of race is purely politico-cultural. The graph produced by the same team clearly shows that there was a large increase in population first between 10,000 years ago and the present, which corresponds to the setting up of new Neolithic economic systems. The second, recent, increase corresponds to the Industrial Revolution.

The Aurignacians, who were all *Homo sapiens sapiens*, created – with some notable regional variations – a culture that was radically different from those linked with the Neanderthals (Mousterian and Châtelperronian). There is certainly evidence of cultural integration in the first Aurignacian industrial settlements of central and eastern Europe, as if there had been some influence from, or assimilation of, pre-existing Mousterian cultural and technical characteristics.

However, the excavations carried out in France and Spain in settlements of the Châtelperronians (the last Neanderthals known in Atlantic Europe) and in the far more numerous sites of the Aurignacian newcomers, who were probably their neighbours for a time before replacing them for good, have highlighted some fundamental differences. There does not seem to have been any cultural exchange between the Châtelperronian Neanderthals, who were still strongly marked by Mousterian culture, and the modern Cro-Magnons, who adopted new tools, better knapping methods, more efficient hunting weapons, a revolutionary way of life and developed figurative art in some of their settlements, by the Vézère, in the Ardèche in France, and in Germany.

The occupation floors of the Aurignacian settlement of Vogelherd in Germany (opposite), clearly dating to more than 30,000 years ago, have yielded an admirable series of ivory animal figurines: horse, feline, bison, mammoth (below). The style of this statuary, perhaps the oldest known, shows the high technical and aesthetic level attained by the Aurignacians, fifteen thousand years

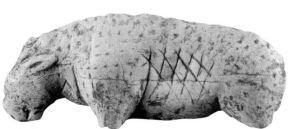

before the Magdalenians of Lascaux. From the very beginning, portable art brings together the characteristics peculiar to Palaeolithic art.

Two representatives of humanity face to face

There is no evidence to establish whether these two very different populations lived at peace or at war with each other for many thousands of years in France and part of Spain. Had the genetic drift of the Neanderthals in the 'land's-end' of Eurasia been in operation since their separation from the common stock of the *Sapiens* several tens of thousands of years earlier in the Near

The signs, criss-cross lines and dots present on the flanks of some of the figurines from the site of Vogelherd also demonstrate the symbolic significance acquired by the very first depictions.

East? Did they come from a different genetic stock from other *Sapiens*, the new immigrants into Europe, so that they were like two distinct species that could not come together? It is disconcerting to imagine these two types of humans face to face, in our part of the world, not so long ago. Certainly we would find it easier to understand

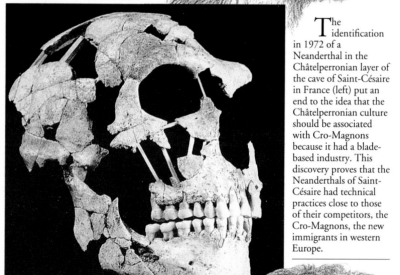

The identification in 1972 of a Neanderthal in the Châtelperronian layer of the cave of Saint-Césaire in France (left) put an end to the idea that the Châtelperronian culture should be associated with Cro-Magnons because it had a blade-based industry. This discovery proves that the Neanderthals of Saint-Césaire had technical practices close to those of their competitors, the Cro-Magnons, the new immigrants in western Europe.

the anatomically modern humans, our ancestors. The Neanderthals differed from the Cro-Magnons in having a more archaic physique (short, muscular and robust) and a brain that was as large, if not larger. The Mousterian industries associated with the Neanderthals

attained a high degree of technical achievement. The silent confrontation between the two populations ended as quietly as it had begun with the rise of the more powerful Cro-Magnons. These people had a more sophisticated social organization and developed artistic feelings.

The Périgord's baby boom

Thanks to the numerous excavations that have been carried out in the region since the very beginning of prehistoric science, the Périgord offers the ideal example of the growth of Cro-Magnon societies. This growth was begun by the Aurignacians, then gradually increased by the Gravettians and the Solutreans, and brought to its highest point by the Magdalenians before the postglacial period, when other societies reached the threshold of economic production.

There seem to be far fewer Châtelperronian sites than Mousterian settlements, which are widely distributed throughout Europe.

In order to be reliable, the reconstruction of prehistoric faces has to be based on fossil specimens. Numerous measurements, facilitated by computer-analysis of images (below), are also taken to produce a model with the characteristics common to all the fossils it is supposed to represent. The anatomical features depend on the cranium: to reconstruct the physical features of Neanderthals – sloping forehead, pronounced eyebrow ridges, projecting lower jaw and lack of chin – various techniques can be used, such as the digitized image reconstructed (below) by 'dressing' a fossil Neanderthal skull with the features of a contemporary man (below left, photograph) or an illustrator's talent (opposite). Yet the soft tissues (cheeks, lips), the skin, its colour, hairiness and hairstyle remain a matter of conjecture, brought to life only by the imagination of the artist or scientist.

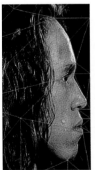 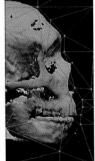 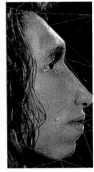

Opposite: Neanderthal man as imagined by early anthropologists (top) and a more recent reconstruction (bottom).

Probably because of the colonizing imperialism of the Cro-Magnons, the Neanderthals do not seem to have evolved in Atlantic Europe after their arrival, though the exact details of this confrontation are still unclear. As the Aurignacian culture spread in the Périgord (and elsewhere), so the number of settlements increased during the coexistence of the two populations and even more during the second half of the Aurignacian. The

population of the naturally protected valleys, glens and coombs is so dense in places – several hundred people – that it forms a continuous human landscape, similar in size to small villages today.

Les Eyzies-de-Tayac in the Vézère valley of the Dordogne was a major site with groups of people often settling next to each other. They appear to have gathered together to profit from the resources of this rich area and to exchange goods by managing the available territory together, at least gradually.

This type of settlement did not yet have the village structure, and later the urban structure, of the Neolithic societies that produced and stored foodstuffs and practised domestication. Nevertheless, it looks like a kind of semi-permanent sedentary community, made possible, as we know, by more productive hunting techniques (and doubtless controlled gathering) and, at the same time, by new social rules, manifested through various symbols: insignia of power, special signs in the caves and on objects....

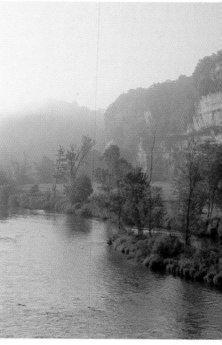

Magdalenian settlement in the Périgord: a new way of life

Excavations of Magdalenian settlements located on hills have enabled archaeologists to bring to light the complexity of the human geography of the Magdalenian Périgord. The open-air camps and dwellings discovered on the top of hills in the Isle Valley correspond to settlements which, while not permanent, were certainly not transient. The pebble pavings, carefully constructed to form insulating and stable hut floors, took a colossal effort that would not be justified

From a very early date – the 1860s onwards – excavators took an interest in the Périgord, an area that had seen human settlement over some hundreds of thousands of years. Large sites, such as the shelter of Laugerie-Basse (opposite top) on the bank of the Vézère (above), provided the first cultural and stratigraphic data from prehistory. Opposite: Palaeolithic settlements in the region.

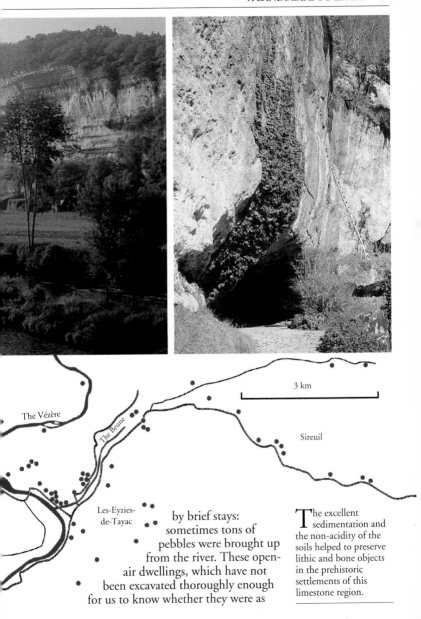

The Vézère

The Beune

3 km

Sireuil

Les-Eyzies-de-Tayac

by brief stays: sometimes tons of pebbles were brought up from the river. These open-air dwellings, which have not been excavated thoroughly enough for us to know whether they were as

The excellent sedimentation and the non-acidity of the soils helped to preserve lithic and bone objects in the prehistoric settlements of this limestone region.

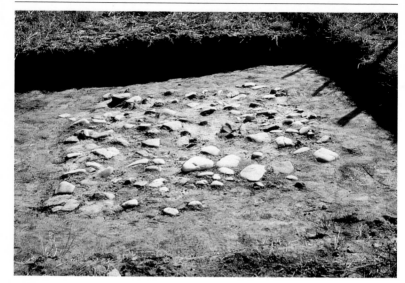

numerous as those set up in rock shelters and at the foot of cliffs, clearly reveal the population growth of the Magdalenians, who were determined to control all accessible places, even those that did not have the natural qualities of their traditional living areas.

In comparison with the Aurignacian colonization by the Cro-Magnons, the Magdalenian settlement of the Périgord represents a far higher – and previously unattained – level of social and economic organization, as shown by the numerous symbolic depictions and

Pavings of quartz pebbles (above, Le Breuil, France), often reddened by fire, appear on the floors of huts built by the Magdalenians who abandoned their tools there. The quadrangular shape of these stone-covered floors is remarkable, and peculiar to the region of the Isle Valley in the Périgord. It differs from the circular huts at the famous Magdalenian site of Pincevent.

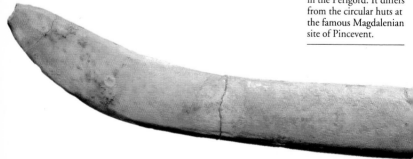

signs as well as the diversity of the remains linked to domestic activities.

Natural resources were exploited using collective methods. Good-quality flint, such as the Bergerac variety, supplies of meat for the population concentrated in a relatively small territory, shells, fossils and rare or unusual stones for the manufacture of jewelry were all obtained through a widespread and tacit system of exchange, a network of contacts, of movements along known routes by the various human groups (tribes or ethnic groups, depending on their size). The population growth of the Magdalenians in the Périgord, and well beyond as far as the eastern extremities of Europe, corresponds to the intensive development of their economic structures and their social organization. The first baby boom of Palaeolithic humanity marks the birth of a better way of living.

The way in which tools are sometimes decorated suits their function. In the paper-knife shape of the smoother from the Grotte Rey in the Dordogne (below), the Magdalenians have cut out a tail fin of a fish at the end of the instrument that was not used, and incised the outline of the animal on the blade. Jewelry provides freedom for creative expression, echoing the highly individual types of body decoration and clothing styles. Some jewelry is influenced by nature, such as this superb ivory pendant from Pair-non-Pair in the Gironde district of France (above), which imitates a Cypraea, a type of shell that was very important to prehistoric people, particularly for its evocation of the female sex. Other pieces, such as this bone pendant from Laugerie-Basse in the Dordogne (left), are pure inventions, often using incised geometric motifs.

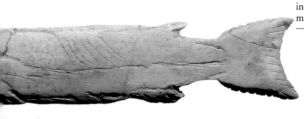

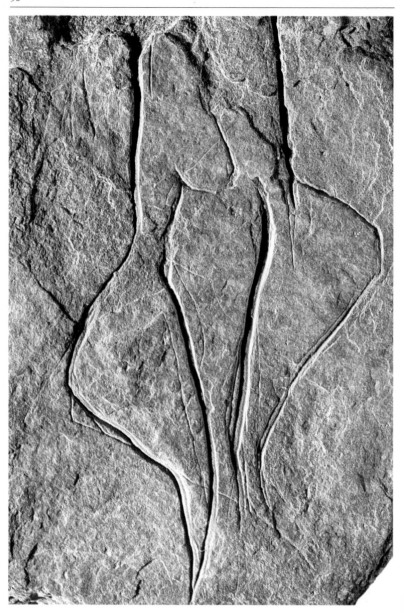

The invasion of the great hunters at the end of the Ice Age brought Europe its modernity, as ethnic groups and cultures started to define their territories. Later, as Upper Palaeolithic societies became more complex in economic and cultural terms, they gradually asserted their different identities.

CHAPTER 3
CULTURES OF EUROPE

Two small stylized female outlines on a schist plaquette from the site of Gönnersdorf (opposite) and large painted signs on a ceiling in the cave of El Castillo (drawing, right) display the magnificent diversity and the symbolic complexity of Magdalenian art.

The weight of tradition

It would be difficult to assign their respective industries to evolved Acheulians or early Mousterians, in northern and south-western France, if their stratigraphic provenance were not known with some precision. There is an imperceptible transition between the tool technology at the end of the Acheulian, which was spread over much of the Old World by *Homo erectus*, and the first Mousterian industries of the Neanderthals, descendants of the former in the same geocultural area.

The two groups worked the same types of tools using identical techniques. The weight of tradition was keenly felt and any changes that there were took place very gradually. Handaxes lasted a long time in some Mousterian industries, although the use of a soft hammer (antler, wood, bone) to finish the knapping brought more gracile and symmetrical forms. It was only later (or elsewhere) that Mousterian industries integrated new tools, in variable ways – tools made on flakes, like sidescrapers and denticulates.

Transmission of knowledge and cultural differences

The Mousterian period flourished in Europe, Asia and Africa with the development of a very special knapping technique that allowed the shape of the flake or point to be predetermined before it was detached from the core. This knapping method, known as the Levallois technique (from Levallois-Perret in the Hauts-de-Seine region of France where the sand quarries yielded a major series of lithic assemblages in the last century), was not practised by all the Mousterians, especially those who were still making handaxes, probably because it is complex, requiring an apprenticeship and the application of a series of ordered actions. The new technique could be learned through apprenticeship, implying a passing on of knowledge which, in itself, was or became exclusive,

Knapping enables people to obtain supports (known as flakes, blades, bladelets) of desired size. These supports are then transformed into tools, scrapers, awls, burins…by retouching their edges and/or their faces. The first stage consists of choosing the hammers, and then the raw materials in outcrops, riverbeds.… Palaeolithic people did not hesitate to travel tens of kilometres to find supplies of top-quality materials. The preparation of the core by smoothing and shaping precedes the actual knapping (below, Levallois core and point).

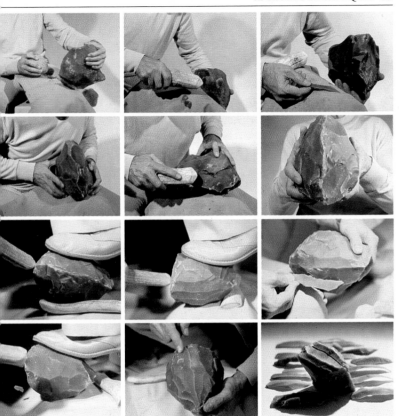

by keeping apart those who were unfamiliar with the techno-cultural milieu from which it arose. The cultural sophistication of the Mousterians in western Europe can be measured in terms of their technical knowledge, so clearly revealed by the Levallois technique and the differences in their tool technology.

It seems likely that the technical innovations of the Mousterian period were the result of broader cultural developments than those provided by simple

The Levallois knapping technique implies technological maturity and assumes the existence of an apprenticeship, long before the development of the blade and bladelet knapping techniques perfected by *Sapiens*. Prehistorians (above) have experimented with these techniques.

56787

In comparison with the Aurignacian figures that reached such high aesthetic standards, the limestone blocks of the Périgord, engraved by other Aurignacians (perhaps contemporaneous or more recent) appear extraordinarily crude. The Périgord group – essentially vulvas, deeply engraved like those of the Blanchard shelters (left), Laugerie-Haute (opposite) and Cellier (below) – is set apart both thematically and stylistically, not only within the vast extent of the Aurignacian culture in Europe, but also during the whole of the Upper Palaeolithic.

technical know-how. New tools obviously correspond to new functions, which represent different ways of life; these people had an ability to adapt to, and exploit, the demands of the environment.

The Aurignacians: an artistic tradition on the banks of the Vézère

The Mousterian tradition showed the first signs of social and ideological behaviour, still too faint to give these people their own cultural identity. It was with the Aurignacians that the notion of cultural territory really took on some meaning.

The art from the Vézère region is very significant in this regard. Nestling in the warm limestone meanders of the Vézère, near Les Eyzies and Sergeac, a handful of rock shelters inhabited by Aurignacians have preserved engravings, incised and put into blocks; some of them are small, and easy to manipulate and transport, while others are far more bulky, and genuinely difficult to move. Stratigraphic studies date them to a period between approximately 30,000 and 25,000 years ago. It is extremely rare to find images of animals on them, and the awkward way in which they are depicted suggests that the artists had little practical or even conceptual experience. However, the seventy or eighty images of vulvas provide evidence of graphic skills, varying between figurative realism and schematic symbolism, unexpected in these early examples of art on stone in the West.

It is impossible to say exactly how long Aurignacian art lasted because of the antiquity of the excavations in these shelters. Yet it is clear that it was confined to an area of some tens of square kilometres, in the immediate proximity of the Vézère, a highly civilized valley if ever there was one. The technical and stylistic similarities of this art between one shelter and another proves that there were close relations between the inhabitants of the different shelters.

Natural space, cultural space

The existence of parietal symbolism helps to define a cultural space in so far as it reveals a common identity

Many people mistakenly believe that the art of Palaeolithic hunters consisted entirely of animals. The engraved vulvas on the limestone blocks found in the sites close to the Vézère are in fact Aurignacian, more than 25–30,000 years old. They are the first iconographic creations of the Upper Palaeolithic. From the very start, sexuality was represented and has continued to have a place in art, right up to today, either explicitly or in the form of taboos. The vulvas and phalluses depicted by Palaeolithic people indicate that the origin of art lies in the body, which creates both meaning and a sense of the future.

in a population that is active for a certain time in a certain geographical area. 'Tectiforms' are particularly revealing in this respect. Tectiforms are complex geometric signs whose shape evoked huts or roofs for the prehistorians of the beginning of this century, who were immersed in the ethnographic comparisons that were in fashion at that time. Up to today, about fifty tectiforms, engraved or drawn in red and black, have been recorded in the Magdalenian parietal layouts of four great Périgord caves: Bernifal, Les Combarelles and Font-de-Gaume (which contains almost half of them),

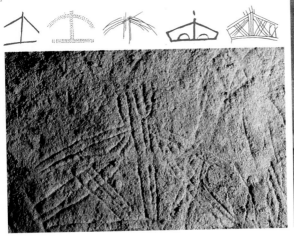

neighbouring caves in the Beune Valley, just near Les Eyzies and Rouffignac, a few kilometres further north. The sign has not been found in the other caves of the region, or elsewhere in the Magdalenian Franco-Iberian provinces. The art of the four Périgord caves has many shared traits in terms of themes and techniques, but each cave is also original. The tectiforms weave a symbolic link between them, as coats of arms or flags would, defining the true group-membership of some people, specifically those who were strangers to the

The elaborate symbolism of complex signs such as the great partitioned rectangles of Altamira (above right) or the tectiforms of Font-de-Gaume (above left) allows regional or even local cultural identities to be distinguished.

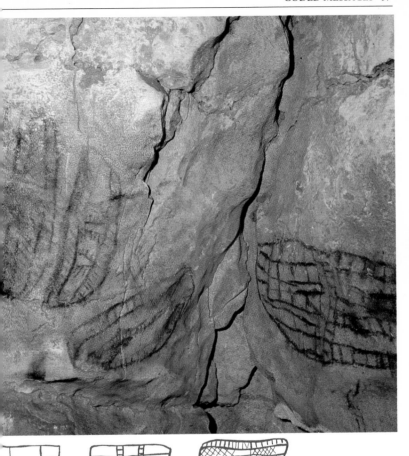

territory and the culture marked by the symbolic emblem. The tectiform signs are the brand of a particular knowledge peculiar to a Magdalenian group, probably over a short span of time, in four neighbouring caves. The notion of territory is thus confirmed in its double meaning, both geographic and cultural.

The graphic construction of the great signs displays variations from site to site, sometimes even within one cave, which doubtless signify symbolic differences within the society that produced them.

Territories and migrations of the claviform sign

A similar situation characterizes the Magdalenian caves with 'claviforms' in the Ariège Pyrenees, which are perhaps contemporaneous with the tectiform caves of the Périgord. The fifty or so claviforms, club-shaped signs (from the Latin *clavus*, 'club') that are engraved or drawn in red (or, rarely, black) in six caves – Niaux, Fontanet, Le Portel, Le Mas-d'Azil, Les Trois-Frères and Le Tuc d'Audoubert – define a symbolism that is peculiar to them and that distinguishes these caves from the others nearby or in the region. Here again, the use of the claviform emblem over a small distance – about 80 kilometres (about 50 miles) – in the limestone foothills of the Pyrenees, which were more densely populated during the Magdalenian than before, provides the boundaries of a space in a specific cultural context.

However, a few claviform signs, painted in red, have been clearly identified in at least two Magdalenian caves in Spain, La Cullalvera (Cantabria) and, particularly, El Pindal (Asturias). They show that geographical and cultural boundaries are not absolute. The presence of claviforms on the Cantabrian coast provides surprising evidence of a symbol that is usually located in underground caves, far away from human contact.

If a comparison is made between the layouts of the Pindal and Niaux caves, where the sign is found, it is

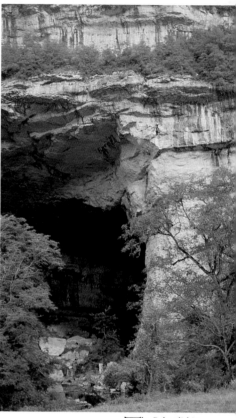

The Palaeolithic hunters rarely lived in caves. However, the immense tunnel of Le Mas-d'Azil (above), dug by the River Arise to a height of 70 metres (230 feet), a width of 80 metres (260 feet) and a length of almost 450 metres (1475 feet), sheltered hundreds of Magdalenians who left many traces of their presence there.

clear that in both cases the claviforms are drawn in red using the same model, and are united by red dotted signs of differing degrees of complexity. These clearly linked themes, repeated several times in two very distant places, cannot be the result of mere coincidence. On the contrary, they are based on the clear decision to reproduce the same coded symbolic message. The claviform, which appears relatively frequently in Magdalenian Ariège, defines a cultural territory. Present in Cantabrian Spain, it bears witness to Magdalenian cultural mobility, without gathering the Magdalenians

The cave of El Pindal in Spain (below) displays in red the original themes from the claviform caves of Ariège: a big sign placed close to six claviforms, the whole being placed beneath a bison marked with an angular sign on its flank (top left of the photo), facing a horse head (top right).

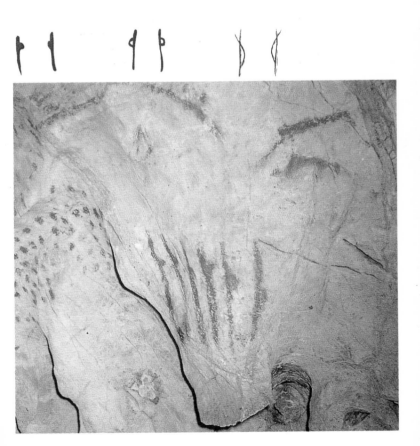

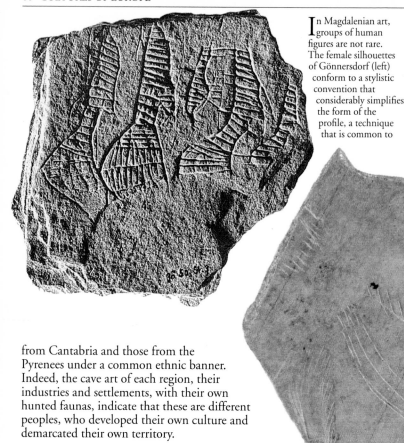

In Magdalenian art, groups of human figures are not rare. The female silhouettes of Gönnersdorf (left) conform to a stylistic convention that considerably simplifies the form of the profile, a technique that is common to from Cantabria and those from the Pyrenees under a common ethnic banner. Indeed, the cave art of each region, their industries and settlements, with their own hunted faunas, indicate that these are different peoples, who developed their own culture and demarcated their own territory.

From clumsy realism to the ideogram: towards abstraction

The Magdalenians of the neighbouring camps of Gönnersdorf and Andernach on the banks of the Rhine (Rhineland), which they occupied about 12,000 years ago, engraved 320 female profiles on schist plaquettes, and carved two dozen figurines in ivory and reindeer antler, and a few others in schist. Some variations are noticeable, in the outlines, though they never affect the disembodied way in which women are depicted: in some examples, legs or arms are dissociated from

several sites from Cantabrian Spain to eastern Germany.

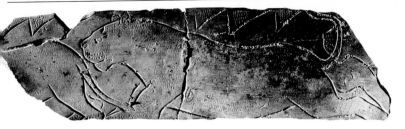

the profile by simple, carefully drawn incised lines; in others, parallel stripes on the body add a geometric effect to the abstract formulation of the outlines.

There is a complete contrast between the ideogram of women, conceived by the Magdalenian

Magdalenian portable art abounds in different forms; depictions of animals are the most numerous, especially on bone supports. Signs often accompany them, a symbolic link that is also found in the caves. Horse heads cut out of bones (left, from Saint-Michel-d'Arudy, France) are a stereotyped theme, principally in the Pyrenees. Nevertheless, engravings on bone or deer antler cover a vast symbolic range, not only in their themes but also in their associations. On the piece from the cave of La Vache (above), the naturalism of the felines, next to the zigzags, reaches a summit of graphic achievement.

hunters, and the realistic images of animals, which were engraved at the same time over and over again, likewise on schist plaquettes.

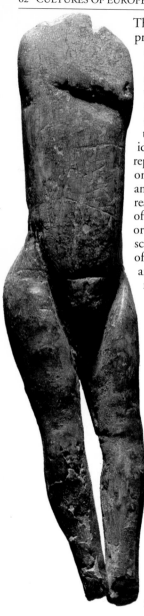

The ideogram of women, present in the two Rhine camps, and in many other sites throughout Europe at the end of the Magdalenian, in no way arises from a degeneration or some kind of evolution of female silhouettes. Before the late appearance of the ideogram, the Magdalenians represented humans in caves, on limestone slabs and blocks, and on objects. There is no real link between the images of humans that they engraved or drew (and very occasionally sculpted). These depictions of humans did not follow any common rules of representation. On the contrary, they show a far greater diversity than the depictions of animals. One common characteristic that all these Magdalenian images of humans share is their lack of realism, sometimes bordering on caricature, or combining human and animal features.

In other words, where depictions of humans were concerned, the imagination of the Magdalenian hunters, and more generally of all prehistoric people throughout the world, turned the human image into a kind of symbolic screen from reality.

Human statuettes from the Magdalenian era are not common, and are totally different. There are no similarities in style between the ivory 'Shameless Venus' from Laugerie-Basse (left) and

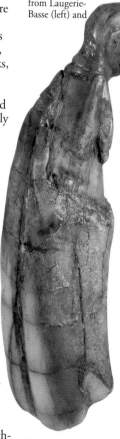

the outline emerging discreetly from a horse incisor at Bédeilhac (above).

Beyond cultural diversity: the idealized image of women

The ideogram invented by the Magdalenians at the end of their cultural period in Europe was a totally new way of portraying humans, quite different from the iconography that preceded it. It was clearly the fruit of abstraction. However, the ideogram of women remained identifiable; in this way it differed from the geometric signs that the Magdalenians had created in profusion.

In fact, signs are far more numerous and varied; their geometric formulation expresses an active process of abstraction, which benefited the image of women. The figurative value of the female ideogram liberated the symbolic power of the idea, which was more independent of styles and of local materials. It became a perfect vehicle for the idealized image of women, which gradually spread over an immense area, providing a standardized concept that symbolized and finally complemented cultural diversity.

The depictions of humans in the Magdalenian caves are as varied as the portable art. Some of them have grotesque or animal features. The artists seem keen to portray animal figures – and indeed masks or strange faces – in an ambiguous way. The only human characteristic in some phantom-like outlines is that they are vertical. Faces, and heads in profile, are relatively common, but almost never realistic: there are no Magdalenian portraits. The two female bodies engraved and sculpted in light relief in the cave of La Magdeleine are exceptions (below). The pose of the woman illustrated here is strangely sensual, with her head resting lightly on her hand, her left arm bent, her torso stiff, legs bent and slightly parted, allowing a finely engraved pubic triangle to be seen. The sensuality suggested by this evocation of the female figure is unique in Palaeolithic art, even though sexuality and the nude were often depicted.

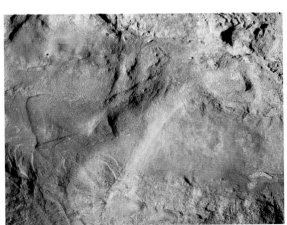

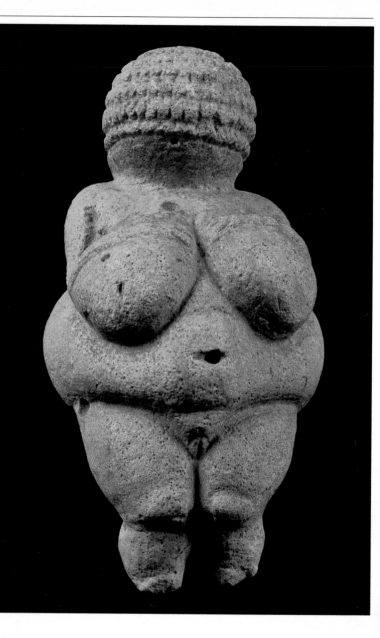

Handaxes, sidescrapers, knapping areas, workshops, huts, hearths, pavings...the long list of remains that have fortunately been preserved celebrates the cultural traditions of prehistoric people as if they were only involved in practical and laborious activities, such as scraping, knapping flint, making fire, hunting and gathering. But what is there to say about the other activities, those that were playful, amorous or symbolic?

CHAPTER 4

THE BODY, CENTRE OF THE UNIVERSE

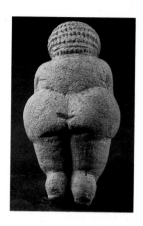

The limestone figurine of Willendorf in Austria (opposite and right) is a reminder that the image of women has been at the heart of art for more than 25,000 years.

Naive anthropology, scholarly anthropology

From the beginning, the image of prehistoric people constantly striving to survive in dangerous or precarious conditions has fired the imagination of prehistorians and still dimly haunts our own civilized selves, we who are so convinced that progress has helped us escape the drama of everyday life in primitive times.

It is easy to understand the unconcealed joy of one of those great pioneers of research, Edouard Piette, when he held in his hand the charming ivory face of the Venus of Brassempouy from France: 'It seems to have been love that encouraged the first sculptor to carve ivory to depict the woman he loved' (1894). The beauty of the figurine transformed these busy brutes into consummate artists, dreaming by their warming fires in those icy nights of bygone times. The aesthetic emotions that are aroused by the marvellous paintings at Lascaux in the Dordogne and by the exceptional wall paintings in Chauvet Cave in the Ardèche bring us closer to this naive vision of prehistoric people, who were divided, like ourselves between the sickly, everyday material world and the timeless spiritual world.

There is a strong contrast between the concealed, spherical head of the woman of Willendorf (previous page) and the angelic face of the Venus of Brassempouy (below), her contemporary, belonging to the Gravettian culture of south-west France. This wonderful face has an almost life-like look, despite the absence of a mouth, which is a feature of the Gravettian statuettes. The head is one of only two portraits of Palaeolithic women known to be in existence; the other is found on an ivory statuette from Avdeevo, in Russia, at the other end of Gravettian era.

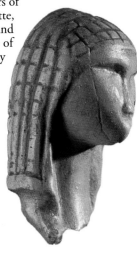

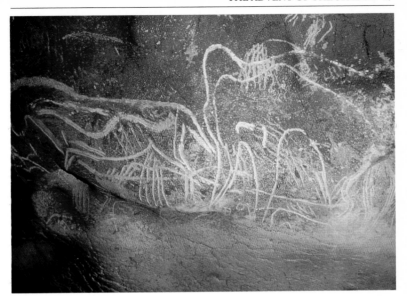

A slow ascent

It is very clear that material matters had the edge over spiritual concerns in the prehistory of humankind, especially in its earliest phases. The subjects of the idea, those that come from inside one's being, those symbols, have only existed for a short time in comparison with the long duration of human evolution, since the first things that were created by the conscious accord of hand and brain – tools. Before about a hundred thousand years ago, and hence before *Sapiens* evolved and spread around the world, there is practically no evidence of any systematic activity of a symbolic nature.

Fossils, rocks with bizarre shapes, pebbles of unusual or vivid colours, picked up by the Mousterians of the Old World provide testimony, albeit modest, to an attitude that is not totally lacking in symbolic significance, in so far as this behaviour does not have any practical purpose.

The dazzling beauty of the paintings and drawings of Chauvet Cave cannot overshadow the quality of the many engravings and drawings traced by a finger or by a tool with a rounded end in the soft coating of some of its walls and ceilings. Among the engraved animals (above, a mammoth and horse) the artists also slipped in some signs. Only an in-depth study of the cave will show whether there are significant differences in theme and style between the paintings and engravings, which, at first sight, do not appear homogeneous.

The symbolism of death

The oldest known graves have been unearthed in cave porches at Mount Carmel in Israel, and dated to between 80,000 and 100,000 years ago. These men of Palestine (*Sapiens*) had been placed in pits dug on purpose, which were subsequently filled in. From their first appearance, burials were carried out in a thorough way, reflecting behaviour that was certainly both complex and symbolic. The burials were a concrete manifestation of significant links – which undoubtedly varied in the course of prehistory – between the living and the dead, gathered together in settlements or in their immediate proximity.

For a long time Mousterian burials remained crude and simple. The use of red ochre to decorate the bottom or the walls of the pit, or the body of the deceased, appears quite late, towards the end of the Mousterian period and almost at the same time as the arrival of modern *Sapiens* in the Mediterranean world. The more elaborate arrangement of tombs through the addition of slabs or plaquettes, and the deposits of offerings at the side of the deceased or on them, only became common with the Cro-Magnons. The symbolism of death developed slowly as *Sapiens* evolved. It finally placed the

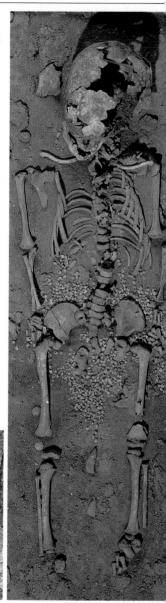

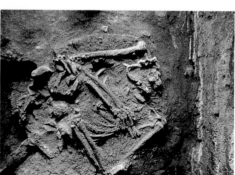

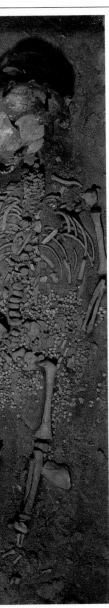

body at the centre of metaphysical preoccupations, and at the heart of the new systems of representation.

When burials speak

The numerous burials of the Pavlovians (between approximately 30,000 and 25,000 years ago) in Moravia, Czech Republic, contained rich funerary deposits, undoubtedly amassed during organized rituals. Pavlovian society certainly appears to have been extremely structured: its vast settlements, like those at Dolní Věstonice and Pavlov, extended for almost 8 kilometres (about 5 miles) and were made up of

The evolution of burials reflects the increasing importance of the collective symbol. The first offerings (antlers, stones, tools, ochre) deposited next to the deceased, such as the burial in a pit at Kebara Cave in Israel (far left), lead on to the ornaments for the body itself, around 40–35,000 years ago (burial of children at Grimaldi Cave, centre, and burial at Barma Grande, in Italy, below). Art is born of this ritual and symbolic relationship with the body.

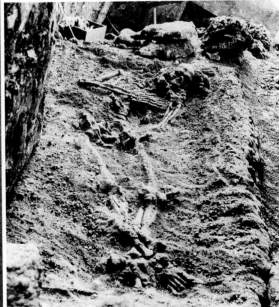

compartmented huts built of mammoth bones and tusks; their agricultural implements and their terracotta figurines anticipate by many millennia the techniques peculiar to some of the Neolithic

Next to the man of Brno II, the Pavlovians deposited a doll with movable parts

people of the world. The hierarchical way in which such a technologically advanced society was organized is reflected in the treatment of the dead, some of whom were buried with jewelry and offerings for the afterlife.

In the great pit – about 4 metres by 2.5 metres (13 by 8 feet) – which they had dug in the floor of their camp, the hunters of Předmostí had buried twelve children and adolescents with eight adults. Curiously, no funerary material was retrieved during the excavation (admittedly an early one, 1894), apart from rare flints, arctic fox bones, and two mammoth shoulder blades found nearby: in this collective burial, one of the largest of the Upper Palaeolithic, the dead had not benefited from any particular care, as if they were anonymous.

Is the extraordinary wealth of offerings given to the man of Brno II (an early discovery of a burial in the

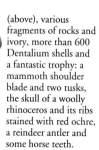

(above), various fragments of rocks and ivory, more than 600 Dentalium shells and a fantastic trophy: a mammoth shoulder blade and two tusks, the skull of a woolly rhinoceros and its ribs stained with red ochre, a reindeer antler and some horse teeth.

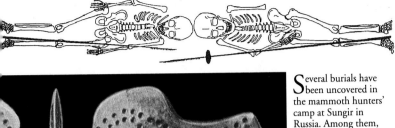

Several burials have been uncovered in the mammoth hunters' camp at Sungir in Russia. Among them, there was an exceptional tomb (above): two children, one aged twelve or thirteen, the other about three years younger. They were placed head to head, clothed and richly adorned: thousands of beads, probably sewn on to their clothing, bracelets, rings on their fingers.... At their sides were daggers, points and spears. Two ivory lances were unusually long – 1.66 metres (5 feet 3 inches) and 2.42 metres (nearly 8 feet) – the result of great technical skill. Finally, there was a horse carved in mammoth ivory, perforated so that it could be hung (above left).

town of Brno itself in the Czech Republic) the mark of honour paid to a chief? It certainly makes the grave stand out, along with those who created it. The tomb was isolated, with no camp in the vicinity, an unusual situation before the appearance of necropolises a few millennia ago.

Together with numerous offerings that spoke of the nutritive and symbolic activities of the living (shells, stones, ivories), the burial included one astonishing piece that is still unique in the prehistory of the great hunters: an ivory statuette of a human, probably male, carved in separate pieces – trunk, limbs, head – that were assembled with movable joints like a doll.

Buried human figurines

Whether sculptured or real, the body was used in all sorts of symbolic ways as more complex patterns of behaviour emerged. A few millennia and some thousands of kilometres separate the Brno burial from the late Gravettian settlements dating to around 23,000–22,000 years ago, for example Avdeevo in Russia. However, archaeologists have found at Avdeevo ivory female figurines buried with a few offerings, flints and animals, in little pits dug for this purpose in the very floor of the immense huts built of mammoth bones and tusks. For the first time, depictions of humans were treated like real humans.

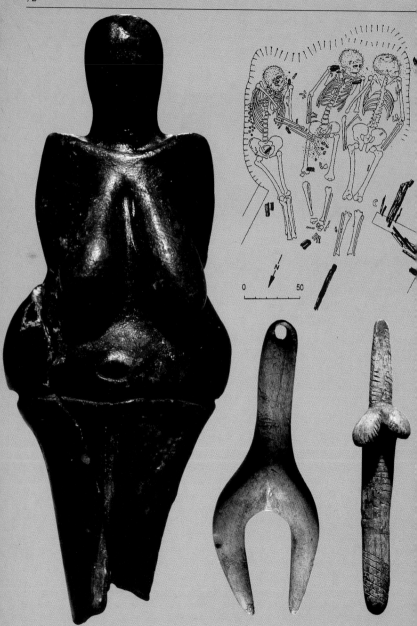

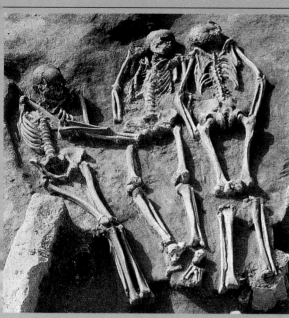

Three Pavlovians, a woman and two men, aged between twenty-three and seventeen, were found buried in a pit with ochre on the ground at Dolní Věstonice in Moravia (left). Their heads were sprinkled with ochre and adorned with the teeth of wolves and foxes. The woman had rickets and a scoliosis (curvature of the spine), and she limped. A cut and burned fragment of a reindeer's penis bone was pushed into her mouth. Beneath her pelvis and between her thighs was a concentration of ochre: a symbol of a childbirth? The hand of the man on her right rested on her pubic bone. A large wooden stake was stuck in the pelvis of the man, a male midwife, according to the prehistorian Bohuslav Klima. The skull of the other man was smashed in. The pieces of wood are the result of the tomb's covering being set alight at the time of the burial. These funerary rites have symbolic and possibly religious significance, also found in the statuettes and pieces of jewelry. They often bear the stamp of sexuality, such as the fired-clay Venus, the amulet that associates the two sexes, the stylized female statuette (opposite) and pendant (left).

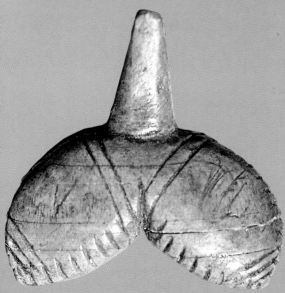

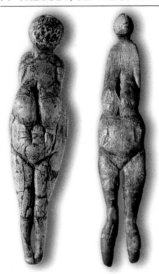

The body glorified

There is evidence that some of the statuettes from Avdeevo, and other comparable specimens in ivory and stone, found especially in the contemporary camps of Kostenki in the Don valley in Russia, had been worn by the living. A perforation made at ankle level enabled them to be hung head downward around the neck of the wearer. Only the wearers could see them the right way up, on their chests. Several of these naked female statuettes, as usual dating from the Palaeolithic period, were themselves adorned with bracelets, belts and necklaces engraved on their skin. The female body, idealized for a first time by three-dimensional sculpture in ivory or stone, was glorified a second time by being adorned as if it were, once again, an authentic living being. Finally, this symbolic expression centred on the body was enriched a third time through the use of the carved and adorned body as living jewelry on real human beings – though

The ivory figurines of Avdeevo (above) and those in stone from Kostenki (opposite) are full of freshness and beauty.

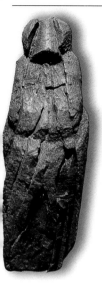

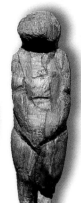

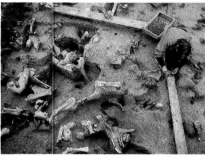

whether on men or women is unknown.
The body was at the heart of the symbolism to do
with the relationship between life and death, as well as
the contacts between the living. The Pavlovians and
Epigravettians of central Europe gave marvellous
expression to these themes.

At Kostenki (above) and elsewhere, dozens of Gravettian and Epigravettian dwellings (from about 28,000 to 18,000 years old) have provided a great deal of information on the domestic activities of their inhabitants, much of it of a symbolic, metaphysical or religious nature. Along with the collapsed framework made of mammoth tusks and bones are the remains of the carcasses of the animals these people dismembered, cut up and ate, the fireplaces, the tools of stone, bone and ivory, the sculpted and engraved objects and jewelry (left, ivory Venuses).

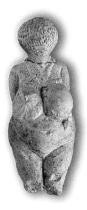

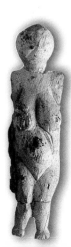

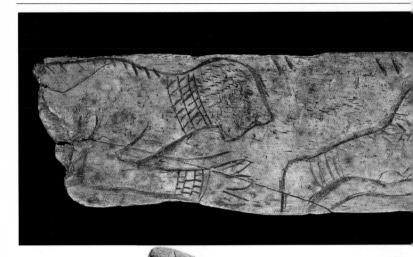

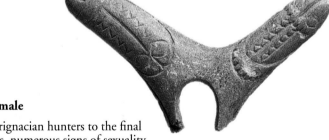

Female and male

From the Aurignacian hunters to the final
Magdalenians, numerous signs of sexuality
mark the depiction of the body, in parallel with
adornments. This double expression of the body's social
significance, jewelry and sexuality, which lies at the very
origins of Palaeolithic art, both figurative and abstract,
still has its place in our modern culture.

The carved vulva depictions of the Aurignacians
from the Vézère are the first intelligible examples of
sexual symbolism. And yet depiction of sexuality was
far from being equally shared between men and women.
Phalluses are rare: a clearly figurative engraving on a
block from the Castanet shelter, an equally evocative
phallus carved in the round from the neighbouring
shelter of Blanchard near Sergeac, and two or three less
explicit engravings on blocks.

There are several
phalluses engraved
on blocks and cave
walls. But the most
spectacular depictions
are carved, like this
Magdalenian perforated
baton of reindeer
antler (above), made
into a double phallus,
from the valley of
Gorge d'Enfer and
the Aurignacian ivory
phallus from the
Blanchard shelter
(opposite).

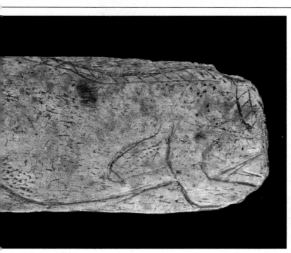

On a bone blade which they cut out and polished, some Magdalenians from Isturitz (Pyrénées-Atlantiques, France) engraved two people in a line (left); the excavators of this rich cave thought it was an 'amorous pursuit'. In fact it is two women; the bevelling, followed by polishing, of the blade at the right end cut one figure at the neck. The barbed sign placed on the thigh recalls the two barbed signs on the flank of one of the two bison in a line, engraved on the other side of the blade: it creates a semantic link between the two figurative depictions, which are symmetrical in terms of composition. At the ankles and wrists there are ornaments whose form or design is identical to those of the necklaces. The animal and apparently hairy head of the woman conforms to the peculiarly Magdalenian practice of giving humans animal features or heads, which they engraved or drew on cave walls.

Gravettian statuary increased this imbalance in favour of women, although less in terms of their sexuality. For the vulva was not frequently incised, and it is exceptional to see it as clearly as on the famous Venus of Willendorf from Austria. Sexual ambivalence is also characteristic of Magdalenian perforated batons, sometimes given explicit expression, as shown by the unfortunately broken implement found in a shelter in the small valley of Gorge d'Enfer, very close to the shelters of Laugerie in the Dordogne, by the side of the Vézère.

Breasts, which the Gravettian sculptors were particularly fond of depicting, were used by the Magdalenians to sex the numerous bodies they engraved or drew on cave walls or on objects, implements, pebbles, plaquettes or blocks. The phallus was employed in the same way; it appears frequently in Magdalenian art.

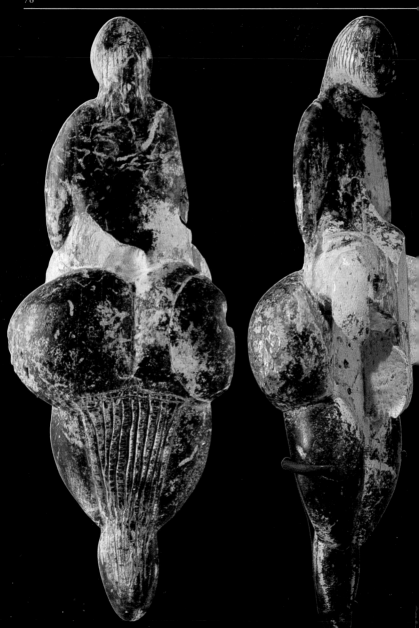

The Venus of Lespugue

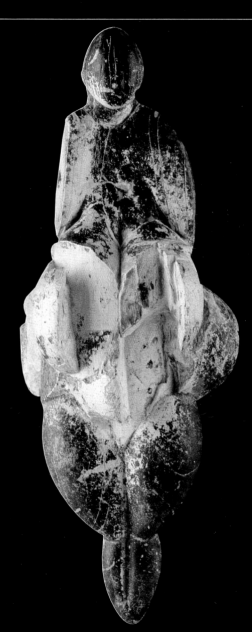

The ivory Venus of Lespugue holds an exceptional place among the masterpieces of prehistoric statuary: it is not comparable to any other Gravettian figurine of its period (about 22,000 years ago). Its tall outline (147 mm; over 5½ inches), larger than that of almost all the Palaeolithic statuettes, provides a pleasant sensation of harmony. The way in which the anatomical parts are organized on several planes of symmetry lends the figurine the modernity of a Cubist composition. The outline is symmetrical on the vertical axis; but in profile the massive buttocks balance the volume of the globular breasts, which partly conceal the abdominal wall. By simply turning the statuette upside down, the 'loincloth' plaited under the buttocks becomes a hairstyle and the feet, carved into a pointed stump, become head and nape. The discreet curve of the shoulders, with the arms scarcely marked, and the almost meditative tilt of the concealed head, contrast with the exaggerated female features of the central part.

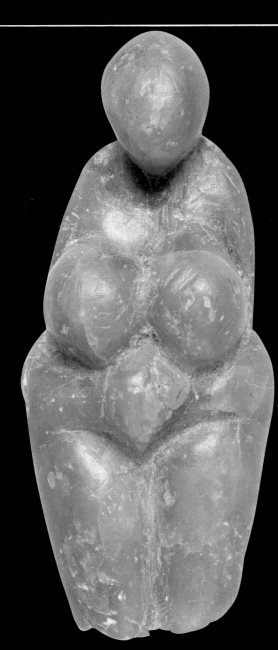

Gravettian female imagery

Gravettian statuary comprises several dozen figurines throughout the whole of Europe. The female image, carved in the round, naked but with its sex rarely marked, sometimes adorned, has become in time and space an original standardized concept. Along with this homogeneity, which may have been mythological at the start, there is diversity of form, albeit with uniform series in certain sites. Hence the Venuses in amber-coloured limestone from Sireuil in the Dordogne (far left), 90 mm (3½ inches) high, and the Venus (80 mm; 3¼ inches) from the nearby shelter of Le Facteur at Tursac (centre) are very similar. Their technical and stylistic roots differentiate them from all the others, such as the plump Venus (left) in yellow steatite from Grimaldi in Italy (47 mm or 1¾ inches, but the legs are broken) or of course the Venus of Lespugue, or indeed the elongated Venuses of Avdeevo. These major stylistic variations tend to suggest that the idea of womanhood, celebrated in three dimensions, circulated more than the works of art.

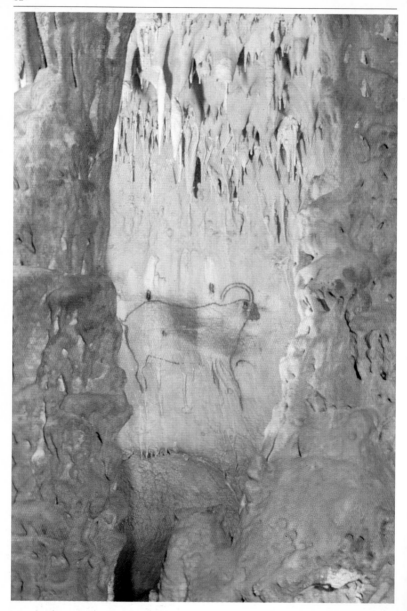

Palaeolithic parietal art is founded on the architecture of the caves, following the natural formations of the rock surface in these remote underground locations. The tortuous, even dangerous passages and the darkness are an integral part of cave art. The whole experience gives this art its meaning, which is surrounded in mystery for many.

CHAPTER 5

PALAEOLITHIC ART, MIRROR OF MEANING

These pits engraved in spirals on an ivory plaque from Mal'ta in Siberia (right) and this ibex drawn in the Cougnac Cave in the Lot (opposite) show some of the diversity of Palaeolithic art, ranging from figurative images of animals to abstract depictions of numbers.

An art that developed where nobody could live for long

Cave art does not appear in accessible places where people gathered. It was hidden away in total darkness, in the isolation of underground passages. Those who wanted to see these images had to go under the earth, forgetting the world of the living for a while, and use artificial light.

Palaeolithic cave art – discreet, hidden, secret – only existed in western Europe. There are about 280 sites, barely a few thousand depictions, the earliest of them probably came from the Aurignacians (Chauvet Cave), others from the Gravettians from 28,000 or 27,000 years ago, then from the Solutreans and finally the Magdalenians, up to 10,000 years ago. In contrast to open-air rock art, which is visible and still partially known on all five continents, underground cave art is cut off from reality; it is located in places where people cannot live for long. This may be why it has special symbolic significance; it is both figurative and abstract, but does not illustrate life.

Figurative but not narrative

Hundreds of images of humans and thousands of animals coexist on the walls of Palaeolithic caves. For the most part, the depictions are assembled in panels, that is, in groupings that frequently followed the natural formations of the walls, vaults, ceilings and, in exceptional cases, the floors. Many are also dispersed through the long and winding galleries of immense caves like Niaux (Ariège), where paintings are found more than 2 kilometres (over one mile) from the entrance, or Rouffignac (Dordogne) whose network of underground caves, over ten kilometres (six miles) in length, was partly exploited by the Magdalenian artists.

Superimposed or juxtaposed, the depictions of animals and humans have no explicit relation- ship with each other. Curiously,

The lamp in pinkish sandstone (below), discovered in the shaft at Lascaux, is marked with a sign painted or engraved in several parts of the cave. Opposite top: the Lion Panel of Chauvet Cave in the Ardèche, found by Jean-Marie Chauvet in 1994.

Palaeolithic cave art, the art of the big-game hunter, depicts neither hunting, neither the hunter, nor the hunted animal. The protagonists are close, and touch, but do not see each other. Animals and humans completely ignore each other on the walls, as if they were floating in space, in a purely imaginary universe.

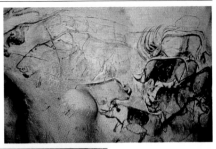

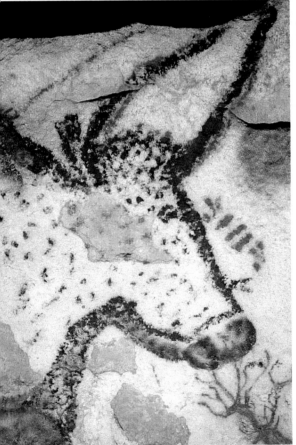

At Lascaux, art takes on monumental proportions. There is a sense of composition in both the long frieze, in a semi-circle, of the Rotunda or the Hall of the Bulls, via the ceiling to the Axial Gallery. The Magdalenians also played with contrasts: small horse/large aurochs, flat-wash/outline drawing, red/black.... This detail of the Rotunda (left) shows some of the cave's major themes: the way images are superimposed and the use of mysterious signs (the horse placed on the aurochs) and the broken-line motif against the bovid's forehead.

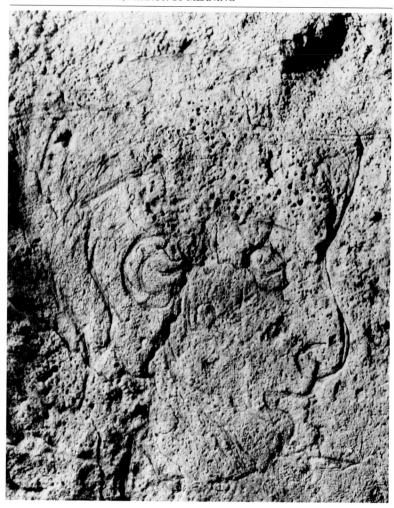

As though they were on Noah's ark, the animals congregate without any fear or aggression. Bison, horses, mammoths, red deer, reindeer…small or large animals, depending on the whim of the artists and despite all natural credibility, are found side by side,

None of the Magdalenian profiles displays the figurative quality of this man's head engraved on a limestone block from the cave of La Marche.

on good terms with felines, bears, birds or fish. The obvious lack of realism in these pictures that never have any landscapes, trees, rivers or horizons is also encountered in the depictions of humans. It is not possible to read any feeling or act into their occasional proximity. Apart from some very rare exceptions, such as the Venus figure holding a horn, carved in bas-relief by a Gravettian at the Laussel shelter in the Dordogne, the hands of Palaeolithic humans are empty, as are their eyes.

Depictions of humans: figurative but subjective

The peculiar nature of figurative cave art, made up only of animals and humans to the exclusion of any objects, weapons or tools, can also be seen in the faces and outlines of the humans, which are completely different from the images of animals. At most one or two faces could pass as realistic; the profiles or the full-face heads of figures with animal features are even less naturalistic.

The outlines are equally improbable, and resemble puppets or simple ghostlike silhouettes. The bodies generally lack anatomical shapes, the limbs are poorly jointed or out of proportion. In the images of humans there seems to be a deliberate desire to move away from the visual objectivity that characterizes the depictions of animals from their earliest appearance more than 30,000 years ago.

Animal depictions: figurative representation

Palaeolithic artists portrayed animals in a naturalistic way, with each culture adopting its own particular style. This dominant figurative tradition was taken to its heights by the Magdalenians.

A confrontation between man and bear is illustrated in a strange way on the two faces of this cut-out and perforated bone disc, found with many other pieces of portable art in the cave of Le Mas-d'Azil. Only the menacing paw of the plantigrade, a regular visitor to the caves, is visible on the fragment. The man, engraved in profile, has the head of an animal; his body is hairy (below right). The other human (below left), somewhat unreal and of indeterminate sex, seems to be full face, with legs apart.

There is remarkable attention to detail: hairs in a bison's ear, a horse's coat, an adipose fin perfectly placed to designate a salmon, or even an anal flap emphasizing the mammoths' ability to adapt to the cold, the stimulated tear-duct of the deer, the powerful ringed horns of the great male ibex. The naturalistic way in which animals are depicted in Palaeolithic art, rarely equalled for its intensity and beauty in other iconographic cultures of prehistory, did not prevent a range of styles from emerging. The heads of the immense aurochs of Lascaux are too small, the humps of the Font-de-Gaume bison are too high, the horns of the rhinoceroses from Chauvet Cave in the Ardèche are enormous…all of these touches reveal the mastery of these prehistoric painters and draughtsmen.

In the depictions of animals in Palaeolithic caves (below, and opposite centre, Lascaux) mammals predominate, and, among them, the large gregarious herbivores. These animals are easy to observe and to hunt. In fact, an enormous number of their bones have been found in Palaeolithic cooking areas, in contrast to the remains of carnivores, which were hunted for their skins and teeth.

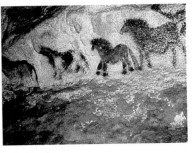

The faithful imitation of nature was associated with the search for visual effect, for artistic effect as it were, although this is an anachronism in relation to prehistoric images.

If the animals are naturalistic, so are their poses. The confrontation of two ibex evokes their rough fights; the line of mammoths calls to mind the majestic and peaceful movements of their herds; the legs of the bison that are folded beneath them reflects the way they roll in the dust; a horse standing behind another recalls a parade. It is hardly surprising that hunters produced these studies of animals, though they are not reproductions of the real world. They are simply brief allusions to it, and are based on the general symbolic presentation of animals, which are utterly removed from their natural surroundings and assembled in accordance with thematic objectives.

Signs: between the geometric and the abstract

It is unbearable to imagine the face of the Mona Lisa scarred by a line of black dashes, or a horse by Delacroix marked with several pairs of dots. In art we have become accustomed to separating the figurative from the non-figurative, with some overlap, as today, between these general categories.

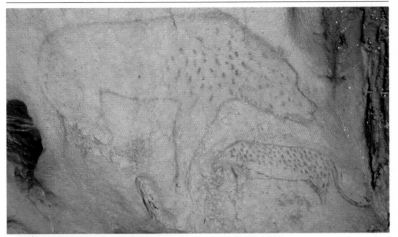

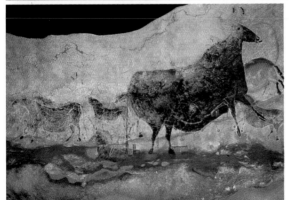

There is a distinct quantitative difference between the images of animals and the fauna that were actually hunted. For example, reindeer, which were hunted more than horses and bison during most of the Upper Palaeolithic in France, are not often depicted on the underground walls. Chauvet Cave (above) contains animals that are rare in parietal art – bears and felines – though they crop up in portable works of art from the Aurignacian (at Vogelherd) or the Gravettian (at Dolní Věstonice). The salmon from Gorge d'Enfer (left), which may be Gravettian, was engraved and sculpted in light relief on the low ceiling of a small shelter.

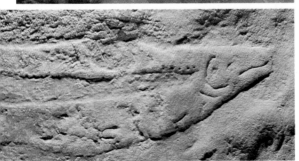

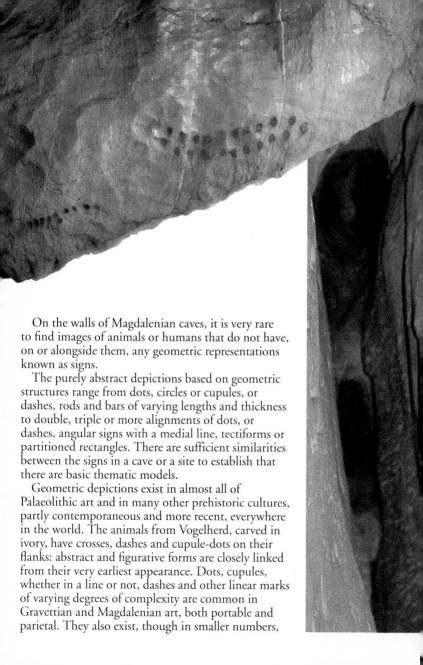

On the walls of Magdalenian caves, it is very rare to find images of animals or humans that do not have, on or alongside them, any geometric representations known as signs.

The purely abstract depictions based on geometric structures range from dots, circles or cupules, or dashes, rods and bars of varying lengths and thickness to double, triple or more alignments of dots, or dashes, angular signs with a medial line, tectiforms or partitioned rectangles. There are sufficient similarities between the signs in a cave or a site to establish that there are basic thematic models.

Geometric depictions exist in almost all of Palaeolithic art and in many other prehistoric cultures, partly contemporaneous and more recent, everywhere in the world. The animals from Vogelherd, carved in ivory, have crosses, dashes and cupule-dots on their flanks: abstract and figurative forms are closely linked from their very earliest appearance. Dots, cupules, whether in a line or not, dashes and other linear marks of varying degrees of complexity are common in Gravettian and Magdalenian art, both portable and parietal. They also exist, though in smaller numbers,

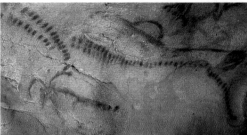

in the Solutrean caves where complex signs begin to appear, like 'aviforms' (in the shape of birds with outspread wings). During the Magdalenian period, signs increase tenfold, and become a kind of cultural emblem.

Mental conception and the attribution of meaning

The use of abstract forms in these Palaeolithic ideograms reveals both the conceptual and social capacity of the Palaeolithic hunters, and their ability to attribute meaning to marks or signs.

Numeration systems are displayed in the numerous series of incised dashes or stamped cupule-dots on

The walls of the caves are not completely covered in images. Palaeolithic artists chose caves for their special topographical features and walls for their particular natural formations, as in the cave of Le Portel, France (above), in which there is a concentration of large signs, including looped claviforms and black animals. In the spacious galleries of Niaux, France (far left), more than a kilometre from the entrance, dotted signs are isolated on a curtain-like vault above the path. Large complex signs, including partitioned rectangulars, were placed on a high and impenetrable geological fault in the cave of La Pasiega in Spain (centre).

bones, lithic plaquettes, adornments or implements and hunting weapons. For the most part, these are short series placed in a line, as if small quantities that could be counted separately were being added to each other. Sometimes there are more complex alignments that meander around the whole of the available surface on the object, and become decorative. Some people have tried – in vain – to see these rhythmic series of incised or stamped small graphic units as precise ways of counting natural or physiological cycles. These interpretations fall apart because of the exact numbers, not because of the appearance of numerical series revealed by these sequences, the oldest of which are Aurignacian. In the caves, the absence of a tight framework evident on objects makes the phenomenon of numeration less perceptible, but it is probable that it is also to be found here through the repetition of aligned pairs of dots or dashes.

Coded messages and animal depictions

The geometric and symbolic abstraction of Palaeolithic ideograms in the caves and on objects turns these abstract signs and animals figures into coded messages. The signs establish symbolic relationships between themselves that can sometimes be very complex, for example on the panel at the Crossroads in the cave of Niaux. They also have close links with animals: tectiforms are associated with mammoths at Bernifal, and with bison at Font-de-Gaume. In the terrible confusion of the panels, containing 318 engraved animals and 620 signs, in the

One of the main characteristics of cave art was the

practice of making good use of the natural rock formations (top).

Magdalenian 'Sanctuary' of Les Trois-Frères, the eleven zigzag signs are always linked to bison. In the Salon Noir of Niaux, the ten curvilinear signs affect that animal's tail, while its flanks bear almost all of the twenty-five angular signs drawn in the vast chamber. Such repetitive spatial relationships between certain abstract themes and certain animals are a clear indication that both are symbolic elements in coded messages, whose significance was clear to the people who produced them.

At times Palaeolithic artists were inspired by the rock surface to create magnificent examples of figurative art. At Pech-Merle in the Lot in France (opposite), a protruding wall in a vast chamber defines the shape of the head, neck and chest of a horse that probably dates from the Gravettian period. Large dots and some hand stencils (not visible here) surround and cover the animal. There is a symbiosis of wall-animal-sign. In a similar way the big red bison from Font-de-Gaume (photo, left, and tracing, below left) takes the size of its disproportionate head, hump and chest from the cave, while its body and shoulder are depicted in red paint. Its flank bears the main types of tectiform signs that are so characteristic of some caves.

The animals and humans are cut off not only from the real world by their representation on the walls, but also from us today, as their message is hidden behind a series of codes or signs.

Far from being the result of a random accumulation of images produced by magic, sorcery or glorification, cave art appears to have a fundamental thematic unity. Cave art has enormous importance because it is constructed.

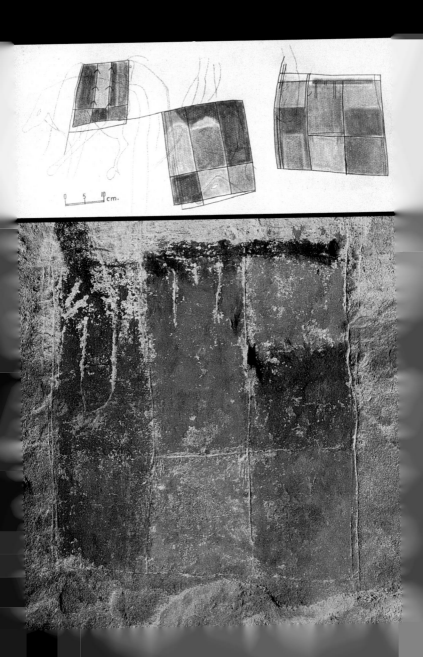

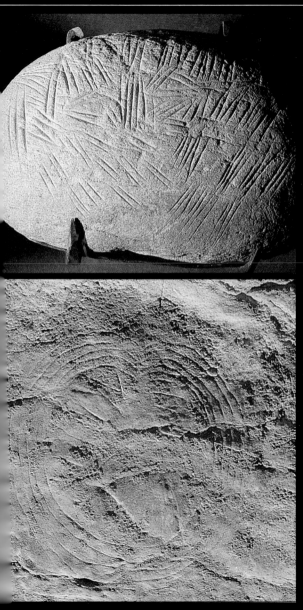

The 'chequerboards' or 'blazons' of Lascaux (opposite top, tracing; opposite bottom, photograph) are some of the most elaborate Palaeolithic signs. At Lascaux, artists made use of several colours – practically a unique feature for signs – that are essential to the composition of the Rotunda and the Axial Gallery. It is curious to find the palette synthesized in the chequerboards and contained in a geometric structure that is made all the clearer by being demarcated by fine but firm incisions.

This engraved structure recurs about forty times in Lascaux, and sometimes in the cave of Le Gabillou in the Dordogne. Like the chequerboard and the engraved partitioned quadrangular sign, the sign composed of circles is peculiar to the cave of Roucadour in the Lot (left) where it is engraved about thirty times; but it is also found in comparable forms at Pech-Merle in the Lot, and in the Cantabrian region. There are also strange motifs on portable supports, as shown by the pebble from Laugerie-Haute in the Dordogne, engraved by the Gravettians (top).

The animal theme

Parietal art in limestone rock shelters is likewise constructed to the same extent. However, few shelters were decorated or have preserved Palaeolithic images. Some often spectacular bas-relief sculptures have been discovered, for example the Magdalenian friezes of Cap Blanc (Dordogne) or Angles-sur-l'Anglin (Vienne). In these shelters, bathed in natural light, as in the cave entrances where Palaeolithic people worked, for example La Lluera (Asturias), Venta de la Perra (Spanish

Signs, animals and sometimes human figures are generally combined on panels or in chambers. The images are rarely grouped according to theme. Few panels consist exclusively of signs or of groups of animals, like the two extraordinary bison modelled in clay by the Magdalenians at the end of the cave of Le Tuc d'Audoubert (below).

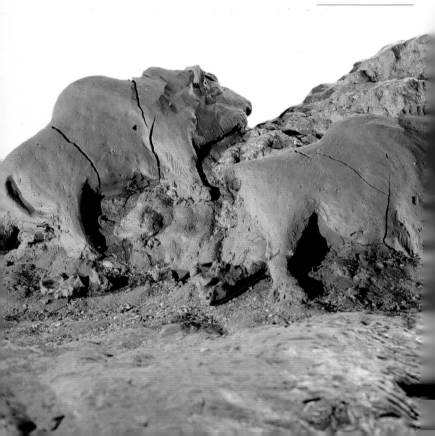

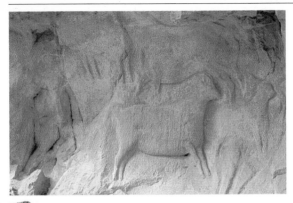

In the rock shelters, animals are the most common theme by far, whereas signs are secondary or even extremely rare. The great Magdalenian shelter of Angles-sur-l'Anglin, a spectacular frieze more than twenty metres (sixty-five feet) long, features bison, horses and ibex, sculpted in relief and engraved, while signs are more or less non-existent. In contrast, humans are illustrated by two or three heads with animal features, a common practice in Magdalenian art, and by four strange evocations of women. Only the legs, thighs, the sexed abdomen and the stomach are depicted. Three women are side by side, and located next to bison; the fourth (above) is placed in front of an ibex sculpted in bas-relief.

Basque country) or La Chaire à Calvin (Charente), animal depictions are omnipresent, majestically arranged in lines when the space in the cave lent itself to this. Apart from some sparse elementary, unstructured lines, there are no geometric signs, or very few, on the walls situated in shadow or semi-darkness of shelters and porches.

Rock art, an art of light

In contrast to the enclosed spaces of the caves, and the somewhat linear walls of the shelters that served as walls, rock art is bathed in light and is open to all viewpoints. Palaeolithic engraved rocks are also dominated by animal images: panels composed of fine incised engravings, such as the rock of Fornols-Haut (Pyrénées-Orientales region of France), or pecked or more broadly incised depictions dispersed in the three great Palaeolithic concentrations

on rocks that are known at present: Domingo García and Siega Verde in Spain, Foz Côa in Portugal. There are cases of basic or simple signs (small cupules, lines and dashes) finding their way into the groups of animal figures, for example a kind of loop at Siega Verde, but never in a spectacular or very visible way.

Clearly, there are strong similarities between Palaeolithic rock art and the contemporaneous cave art in the choice of animal images and the absence of scenes from the hunters' life. However, rock art differs profoundly from cave art because there are very few geometric or human representations. It does not seem to follow the same code that is based on the complex interplay between animals (sometimes humans) and signs.

In the rock art sites, the images are scattered over tens of rocks, probably hundreds of them at Foz Côa and Siega Verde; they are only linked together by a common style and theme – animals that are particularly dominated by aurochs, horses and red deer. At Siega Verde,

The discovery of the engravings of Foz Côa, Portugal, in 1994 gave Palaeolithic art the dimension that it seemed to be lacking: space, in the open air. Certainly a few rare sites had already shown that open-air rocks existed with engravings of

the engraved schist rocks are situated very close to a bank of the river Agueda, which forms a natural link between them that stretches for more than a kilometre (about half a mile), but the engravings at Foz Côa are dispersed among numerous schist rocks in the steep-sided valley of the Côa for more than 15 kilometres (9 miles).

Lascaux, the archetypal cave

Lascaux combines in a harmonious way the main features of parietal constructions: entrances and depths, corridors and galleries, low and narrow passages that favour the development of the layout or the sweep of images from the walls to the vaults, chambers that enclose the observer in a hollow space where the depictions on the walls are interlinked and respond to each other. In the chambers observers only need to make a panoramic sweep with their eyes to take in the images created there; these representations are either separated from each other or grouped in panels. By contrast, the images scattered in the galleries are only visible gradually as observers go further underground. It takes time to make a

animals in Palaeolithic style. But the rock art of Foz Côa displays the monumentality of the world's great concentrations of rock art, in Australia or in the Tassili, for example. The 'monument' is the whole valley (far left), deep and with steep sloping sides, filled with an infinite chaos of rocks. These are schists, a rock that offers naturally flat, almost smooth surfaces that are virtually blackboards. On them Palaeolithic people drew animal outlines, mainly aurochs, ibex, horses and red deer (above, top and left), by making deep incisions, or peckings, and then often polishing them.

symbolic link between some of them, while there is an immediate connection between others the moment they are seen in the light. The architecture of the caves influences the arrangement of the works of art, which are positioned from the entrance to the far end, so that observers can move about or find temporary rest. Within this architectural model, common to all the caves, there are numerous variations: some are natural, resulting from the forms of the networks and their walls, others are purely cultural, resulting from the choices made by people.

Entrance airlock

The general plan of Lascaux shows the remarkable alternation of chambers and galleries. The natural architecture of the cave had a profound influence on the distribution of the cave art: the largest animals are painted in a semi-circular frieze in the Rotunda or Hall of the Bulls (below).

10 m
32 ft

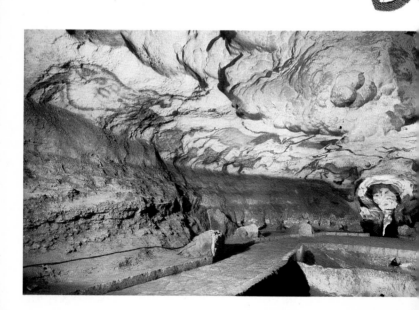

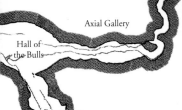

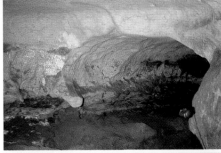

Chamber of the Felines

The 'Sanctuary'

In certain caves, there is a clear symbiotic relationship between the layout of figures and the natural features of the cave; it is easy to understand the symbolic construction of the 'Sanctuary' (to use the term employed by the French archaeologist André Leroi-Gourhan), that is, of a particular place in the cave that was evidently given a special social function. In the simplest case a dominant theme is concentrated in one sector of the underground network. At the cave of Altamira (Cantabria, Spain) about twenty red and black bison and the twenty red signs associated with them leave very little space for a hind, two horses and a boar on the ceiling of a hundred square metres (over a thousand square feet); in the final gallery of the cave, a few big black quadrangular signs and two black masks

Lascaux contains various examples of art in different areas – a semi-circular frieze in the Hall of the Bulls (opposite), bilateral paintings in the Axial Gallery and, primarily, engravings in the low narrow passageway as well as in the Chamber of the Felines. In the Nave (above and top), which is high and wide, paintings and engravings are found together, mainly on the left wall, which is the more accessible. The Apse has hundreds of engravings and paintings, from floor level to the centre of the ceiling. The Shaft is at a lower level.

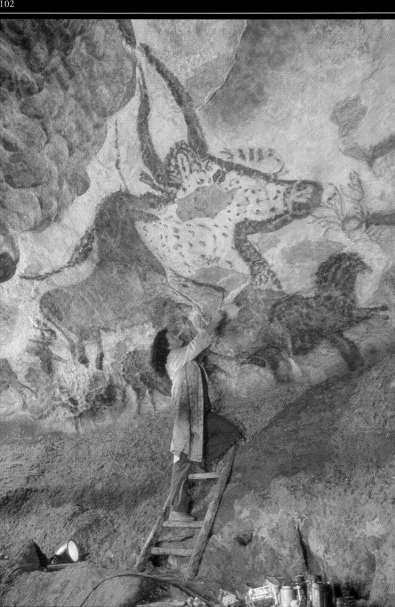

The replica of Lascaux is a good example of the benefits of bringing together art and research. The cave was closed to the public in 1963 as a result of damage to the walls. The huge numbers of tourists who had entered the cave had caused biological contamination, which could be seen particularly in the proliferation of micro-organisms, the 'green sickness'. At the same time, the impact on the temperature and humidity of the cave resulted in the rapid growth in micro-concretions, the 'white sickness'. The exact replica of the cave, Lascaux II, was created close to the original site. Thanks to numerous measurements and topographic readings by photogrammetry, it was possible to construct a rigid shell, with the actual shapes and dimensions of the Rotunda and Axial Gallery. It was then left to the sculptor Renaud Sanson to prepare the shell by reproducing the wall itself, its grain, its concretions (left). On the walls of this artificial cave, the painter Monique Peytral (opposite) then executed the paintings with the same precision.

constitute the main works of art. There is certainly a contrast between the images on the ceiling and those in the deep gallery.

In the Ariège cave of Le Portel, the numbers of horses and bison are reversed from one gallery to another: 3 horses and 8 bison in the first, 9 horses and 1 bison in the second, 11 horses and 2 bison in the third, and finally 3 horses and 12 bison in the last. From this arrangement a basic thematic organization emerges. It is structured around separate topographic

The Magdalenians created the masterpiece of Altamira (below and opposite), the bichrome bison and the large red signs on the ceiling while lying on the ground. They could not see their work as a whole, as the floor was, at the time, only a metre from the ceiling.

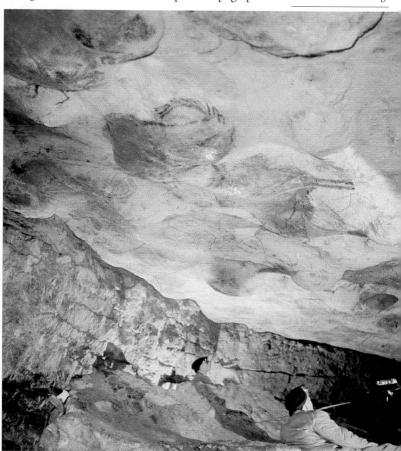

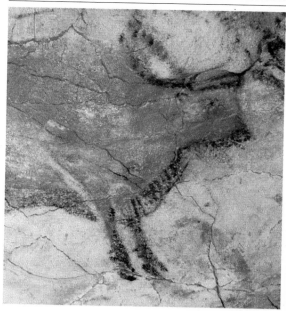

The cave of Le Portel (below) is shaped like a trident. The paintings, drawings and engravings by the Magdalenians are found along the central axis and in the galleries, which are more narrow and winding. Two of them contain almost all the bison, the other two the horses. These two species, so often depicted together in Palaeolithic art, are treated differently here.

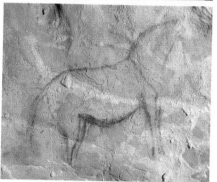

units (the galleries) and founded on a clear thematic contrast between the themes of bison and horse, independently of other animal themes (deer, ibex, fish and owl).

The cave of Niaux, which has 460 animals and signs, mostly painted in red and black, but with a few drawn on the sandy floor, provides a good example of a very developed symbolic structure that extends throughout its network of over 2 kilometres (over 1¼ miles). It is exemplary, partly because of the clear division of the underground space into galleries and chambers, and partly because of the cultural homogeneity of the works produced between about 13,000 and 12,000 years ago, according to the dates obtained from black charcoal lines in the Salon Noir.

Black-animal-chamber and red-sign-gallery

The Salon Noir of Niaux, a vast and high chamber located at the end of a wide lateral gallery in the network, contains – in a few panels completely separated from each other by the natural rock formations – about half of all the mainly monochrome paintings in the cave. Yet red was used almost exclusively in the galleries. There is a clear division in the arrangement of the cave art into two equal parts between red and black and between an immense space where one can move freely and an enclosed, albeit majestic space. About eighty per cent of the 107 animals are located in the Salon Noir and the immediate approaches, while almost two thirds of the signs are scattered through the galleries. The cave of Niaux presents a model of Magdalenian graphic symbolism that could be summarized as follows: black-animal-chamber and red-sign-gallery.

The dots that represent thirty per cent of the 340 signs in the caves are usually located in the galleries, more particularly before and just after the great Crossroads where the climb to the Salon Noir begins, whereas the linear signs, which add up to almost half of the signs, are situated primarily in the Salon Noir, which is closely linked with the animals. A new pattern emerges: dots-red-galleries and black linear signs-black animals-chamber.

The discovery of an intentional layout

Elaborate signs, although less numerous, are nevertheless a determining factor in understanding the symbolic and more complicated way in which the sanctuary was laid out. Angular signs, which comprise eleven per cent of all of the signs, are almost entirely located in the Salon Noir and are mostly associated with the bison. This special link between bison and angular

Located between the two Crossroads of Niaux, the deep gallery contains four red branching signs. This type of sign is somewhat rare, though comparable examples have been found at Lascaux. The branching signs are sufficient to set Niaux apart from other Magdalenian caves in Ariège. In a lateral recess and on low pendant rock overhangs (left and opposite) are two of the branching signs; one is vertical, framed by its

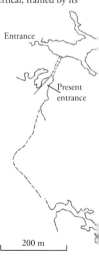

support, while the other is placed horizontally under the neck-and-back line of an animal that cannot be identified.

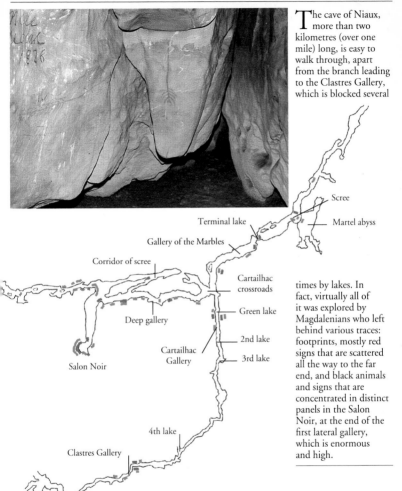

The cave of Niaux, more than two kilometres (over one mile) long, is easy to walk through, apart from the branch leading to the Clastres Gallery, which is blocked several times by lakes. In fact, virtually all of it was explored by Magdalenians who left behind various traces: footprints, mostly red signs that are scattered all the way to the far end, and black animals and signs that are concentrated in distinct panels in the Salon Noir, at the end of the first lateral gallery, which is enormous and high.

signs is found repeated in the 'bison with cupules', drawn in the floor of the deep gallery, which denotes its symbolic strength. The angular signs are drawn in black, except for eight of the nine signs with a short medial line, associated with the bison but also with one

horse in the Salon Noir. Five branching or feathery signs were drawn in red, exclusively in the galleries. The fifteen claviforms of Niaux provide one final key in examining the symbolic layout of the cave. They are all red, including the three placed in a marginal position in the Salon Noir: one is stuck in the back of one of the rare isolated bison at the start of this arrangement, and two are associated with lines of red dots, hidden in a vertical fault away from the panels of animals and signs. The location of claviforms in the galleries is linked to the dotted signs. Finally, by studying the technical (colours), thematic and topographic parameters employed by the Magdalenians, it is possible to discover Niaux's deliberate ritual system: it is clear from the numerous thematic links systematically found throughout the cave, even in its remotest recesses, that the works of art were laid out in a symbolic way.

Lascaux, which has a thousand works of art, both majestically composed paintings and an intimate confusion of engravings, distributed in panels that are laid out rhythmically by the cave's varied architecture, was constructed as carefully as Niaux. Lascaux and Niaux, like so many first-rate Palaeolithic caves, show that the symbolic arrangement of the images is based on a basic thematic model that is adapted to the natural shape of the walls.

The mirror of meaning

Palaeolithic art – an art in code without words – remains indecipherable. Nevertheless, there is certainly some underlying meaning behind the numerous images and their distribution on the walls. Palaeolithic art does not reflect the everyday life of the hunters who produced it, yet it is intimately linked to them, and is an expression of their own social rules.

Two bison-men engraved in the Sanctuary of Les Trois-Frères, Ariège, together with a third engraved in the older Magdalenian cave of Le Gabillou and a few rare beings with combined human and animal features, cannot provide sufficient evidence to substantiate the idea that shamanism underlies Palaeolithic art. Similarly, the model of a bear riddled with blows from a spear that was found in the immense Magdalenian

Several drawings made in the sandy floors of Niaux, in the Salon Noir and in the galleries were not destroyed by visitors or the development of the site. Among them is the 'bison with cupules' (opposite). The cupules are actually little funnels hollowed out by drainage. One cupule became the bison's eye, while others turned into angular signs.

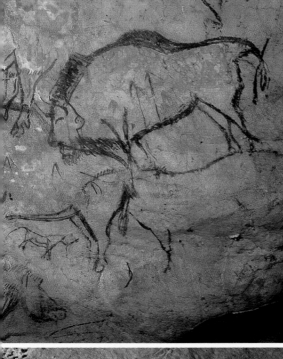

The 'great calcited panel' of the Salon Noir in the cave of Niaux (left) uses symmetry and superimposition in its composition. Two bison heads overlap in an astonishing graphic game. The bison facing right is reduced to its upper outline; above it, another bison is depicted only by its lower part. Cave art is clearly an art of composition, which was invested in the monumental architecture of the caves.

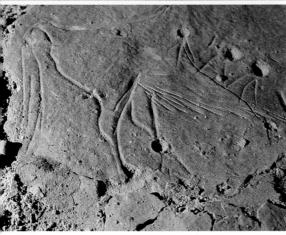

cave of Montespan, and a few other 'wounded' depictions here and there, cannot justify interpreting Palaeolithic art as having a religious or magical purpose.

It is quite probable that magic rituals took place in these hunting communities that were dependent on a largely uncertain self-sufficiency, and also that shamans may have exerted religious powers on people and animals. Indeed, several clues found in burials and in settlements might lead to this conclusion, but this is simply not the case with their art. There is a wide gap between the imagination and the life of Palaeolithic people.

If cave art and portable art had reflected the life of Palaeolithic people, they would have been narrative and

In Game Pass rock shelter, South Africa, a shaman with eland feet holds the tail of a collapsing and dying eland (below). The ivory statuette from Hohlenstein-Stadel in Germany (opposite) is no less strange. This Aurignacian man with

the head of a lioness is carved from the tusk of a mammoth. In the cave of Montespan, the bear modelled in clay is riddled with spear-thrusts, blows struck by Magdalenians as if to kill the spirit of this carnivore (left). In modern and prehistoric times, art bears witness to the intimate relationship between the hunter and the animal, the spirit and reality, the imagination and beauty. Page 112: head of a man from Saint-Cirq, France.

homogeneous because of the stable way of life led by the Ice Age hunters in Europe. However, cave art and portable art mirror people's thoughts and their most intimate beliefs; hence their fundamental diversity, despite the uniformity of techniques and the limited number of themes – animals, humans and basic signs.

The layout of the cave art brings together in a symbolic way the images, the figures,

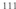

the systems of thought and belief that these communities produced. Organized around themes and architecture that were deliberately chosen and combined, the symbolic constructions became myths themselves. In the secret darkness of the underground world, the Palaeolithic people of western Europe created their history and discovered their identity.

For the first time in the long prehistory of humankind, the imagination transformed the myth, the image incarnated the meaning. *Sapiens* then transformed the world in their own image. That was yesterday, the dawn of our modernity.

DOCUMENTS

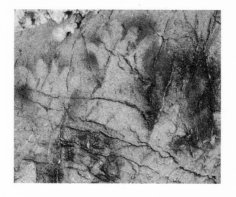

The origins of modern humans

Palaeoanthropology has to base its theories on the incomplete fossil evidence that remains from prehistoric times; it also has to free itself as far as possible from the ideological, cultural, intellectual or even religious baggage that influences people's ideas of human evolution. Today there are two rival views that attempt to explain the origins of Homo sapiens sapiens.

Skull of a Cro-Magnon.

What skulls tell us

Anthropologists place all present-day humans in the single subspecies *Homo sapiens sapiens*, more commonly called [anatomically] modern humans. This subspecies includes, obviously, all living humans, but also all their predecessors who resembled present-day humans. As we only know about past populations from skeletons, it is from bones alone that we can reach a diagnosis that embraces all modern humans. This diagnosis is based, essentially if not exclusively, on the skull, and its principal characteristics are the following:

– first, a very special bony architecture of the skull, giving it a very rounded general shape with a curvature towards the base of the occipital area, a greatly developed anterior (i.e. frontal) part of the brain, but a reduced face;

– second, a general gracility, since the bones and especially those of the skullcap, are rather thin; the bony reliefs such as the brow ridge or the occipitals are not very marked;

– finally, a fundamental characteristic, perhaps the most important one, a very great cerebral cavity, and hence a voluminous brain.

Yet the notion of resemblance, mentioned above in definition of the subspecies, nevertheless raises a certain number of difficulties, particularly in knowing at what point the resemblance diminishes sufficiently to become a difference. In other words, when does one pass from one taxon [or similar group] to another?

What was there before modern humans?

If we go back far enough in time, between 300,000 and 400,000 years, we

find the first representatives of the species *Homo sapiens*, those we have traditionally called archaic *Homo sapiens*. They already have the shape described above, but the brain, though it is large, has not reached its present size, and another important difference is to be found in the enormous development of the bones, particularly the bony superstructures: the cranial walls are very thick, and there is a prominent brow ridge that takes the form of a torus – that is, a continuous transverse bar above the eye sockets.

When we go even further back in time, we find very different fossils, from *Homo erectus*, generally considered to be another species. The shape has completely changed: the curvature of the occipital area is far less marked, the cranial vault is very low, the face juts out much more, there are considerable bony superstructures, and cranial capacity is small, around 900 cc, whereas that of present-day people averages 1450 cc.

So human evolution passed from *Homo erectus*, with their very archaic form, small brain and very robust physique, to archaic *Homo sapiens*, with a larger brain and transformed cranium, although it remained extremely robust. These forms were succeeded by *Homo sapiens*, known as modern humans because they resemble us, with a less robust physique.

For a very long time, these modern humans were believed to have appeared recently. Since the birth of human palaeontology, or palaeoanthropology, and until the mid-twentieth century, the classic view was that there was a linear succession of forms that fitted together as one went back in time. Modern humans, who had succeeded the Neanderthals, appeared most recently, around 35,000 to 40,000 years ago.

One of the major contributions of the past fifteen years has been to modify completely – indeed shatter – this traditional scheme, and push back the origins of modern humans by 60,000 to 65,000 years, thanks to progress in excavation techniques and absolute dating methods. Fossils in Africa as well as in the Near East, and to a lesser degree in Asia, have proved that people with modern characteristics lived at least 100,000 years ago.

The two theories on the origins of modern humans

The problem that now confronts us is that of origins. Where did these modern humans come from?

Some believe that modern humans have a single point of origin, most probably Africa and, more specifically, sub-Saharan Africa. The migration is thought to have taken place about 100,000 to 200,000 years ago. It was from this single centre of development that modern humans spread through the whole of the Old World, taking the place of the local populations of archaic *Homo sapiens* who lived in the regions they reached.

This theory has been given the evocative name of 'Noah's Ark' ['Out of Africa' or 'population replacement' model], as it implies that the new population originated in one single area and later replaced all other populations on Earth. This theory particularly enjoys the support of geneticists.

Others – mostly anthropologists – believe that modern humans evolved gradually in several regions of the Old World from archaic *Homo sapiens* who inhabited these areas. According to this second theory, modern humans were all derived from one single archaic species; but this species evolved simultaneously,

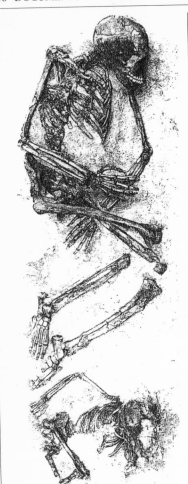

D̲ouble burial at Qafzeh Cave near Nazareth, with two early representatives of our species, *Homo sapiens*, dating back almost 100,000 years.

This theory too has been given a vivid name: it is called the 'candelabra' [or 'regional continuity'] model, which illustrates the existence of several series, evolving in parallel, and ending in similar but distinct results.

Which theory to choose?

What are the arguments in favour of each theory?

It is absolutely clear that no decisive proof exists at present because, if that were the case, all anthropologists and all geneticists would already be in agreement. Which theory one chooses depends on the way in which one interprets the current evidence, which is still incomplete.... However, one fact appears indisputable: fossils will finally enable us to find the solution to the problem. When palaeoanthropology has a sufficient quantity of well-dated fossils, when it can reconstruct from a significant number of pieces of evidence the successive populations, and describe with some certainty the transformations that they underwent or the migrating people who replaced them, there will no longer be any uncertainty about the routes that led to modern humans.

The geneticists base their view on a number of highly relevant observations. By studying the difference in genetic make-up among present-day populations, they work out exactly when the different populations acquired their individuality. This work involves mitochondrial DNA and nuclear DNA. For example, some researchers who have studied the polymorphism of the genes of ß-globin have shown a greater diversity in African populations than in others. For this reason African populations must have a more ancient origin.

or with slight time lags, in the different regions of the Old World where it lived and finally became modern humans.

This scheme does not lack coherence; but it is also necessary to determine the time it would have taken for the transformations in question to have happened and spread. Unfortunately the geneticists lack the means of measuring time with any precision. They certainly have molecular clocks or genetic clocks, but these are usually uncertain and imprecise. Calculations based on an evaluation of the mutation rates per unit of time show that modern humans originated between 140,000 and 290,000 years ago.

It therefore seems safer to interpret the evidence left by fossils, although unfortunately too few have been unearthed at the present time.

Bernard Vandermeersch
Les Conférences de la Société philomathique de Paris-IV, 1994

V arious human skulls belonging to our prehistoric ancestors.

For a theory of Palaeolithic art

Rather than ascribing to prehistoric humans the thoughts and words of present-day people, whether western or 'primitive', as his predecessors had done, André Leroi-Gourhan chose to study the patterns in the art of Palaeolithic people.

André Leroi-Gourhan at his desk.

The publication of The Art of Prehistoric Man in Western Europe *revolutionized the analysis of Palaeolithic art by showing that it had not originated out of magical practices, but out of a dualistic concept of the universe, governed by two complementary principles, male and female. Leroi-Gourhan came to the conclusion that Palaeolithic art had avoided renewing its techniques, and consequently that it had a continuous evolution. Today, this globalized interpretation has been abandoned in favour of a view that takes account of the cultural context and of regional identities.*

Cultural continuity

Those who see primitive society as made up of widely separated wandering hordes tirelessly pursuing their quarry over vast empty reaches of tundra are due for a surprise. In western Europe, at least, where numerous geographical obstacles served to cut off regions one from another, stable traditions over many thousands of years led to the maturing of a symbolism absolutely continuous in development from the earliest artistic manifestations down to the end of the Magdalenian period. This continuity is all the more striking because the material equipment of the prehistoric cultures was periodically altered: this is what the scholarly division of prehistory into periods – Chatelperronian, Aurignacian, Gravettian, Solutrean, Magdalenian – brings to our attention. These divisions now and again give rise to popular notions of successive waves of prehistoric peoples appearing out of nowhere, sweeping away their predecessors, and triumphantly introducing a new civilization. However attractive to the imagination, this conception of repeated racial upheavals

is probably without foundation in reality. It is as though some archaeologist of the future, attempting to make sense of our history in a dramatic manner, were to formulate the following chronological sequence: Age of the Bow, Age of the Crossbow, Age of the Musket, Age of the Rifle, Age of the Intercontinental Ballistic Missile, and so on. He would thereby call attention to successive changes in our military equipment, but meanwhile he would distract attention from the actual continuity of our languages and religious traditions over the same period. We must keep in mind the similar character of the divisions of prehistory. 'Aurignacian' does not indicate a racial or ethnic type of man, or a language, but primarily a type of spear. Beneath the surface of sharp chronological divisions such as this, which are derived from technology (mostly from hunting techniques), everything else of which we now have evidence testifies to a continuity comparable to that linking twentieth-century western Europeans with their Merovingian ancestors. Moreover, the clearest evidence for this continuity is supplied by art. Attempts are still being made to discover a typically Solutrean or typically Magdalenian art, but in fact Paleolithic works follow one another in imperceptible gradations that submerge the technologists' divisions. The first thesis that we shall defend here is that the evolution of European Paleolithic art is homogeneous and continuous and that it implies the cultural continuity and homogeneity of the human groups that produced it. One or another type of weapon may have come in from the east or the south and been enthusiastically adopted while the thread of the religious traditions upon which artistic traditions were founded remained unbroken....

Motives for the creation of art

It would be only too easy to criticize those who at the beginning of this century set out to construct a prehistoric man patched together from Australian, Eskimo, and Lapp components; it would also be most unfair. The scientific mind can build only on known facts: to be allowed to head the list of primitive peoples, Cro-Magnon man had first to submit his biography. He supplied us with chipped flints, ivory spears, and reindeer bones by the thousands, and with incised images of animals by the hundreds; he did not think of supplying us with so much as a hint as to the purpose these served. So ethnography was called upon to supply the living context which these surviving evidences presume. To the Abbé Breuil goes most of the credit for having tirelessly explored the primitive world known to his own day in search of data capable of restoring some sort of life, however artificially, to prehistoric man. We are indebted to him for nearly everything we have learned about Paleolithic art, as well as for the major part of the efforts yet made to explain it. Once restored to life, prehistoric man inevitably found his way into literature, and the composite image has taken on the status of historical reality. A new folklore about our ancestors was brought into being, though the earlier one involving 'art schools' and 'sketchbooks' did not entirely die out. Stone Age man, as restored by Breuil, has the merit of plausibility, at least. We see him as a hunter going down into a cave to paint a wounded bison on the walls – incontestable evidence of sympathetic magic. We see him painting signs, more

or less geometric, which are interpreted by some as portrayals of his own dwellings, by others as animal snares or dwelling places of spirits. We see him reproducing the image of pregnant mares in order to secure the fertility of the game he hunts. We see him dancing, wearing a horned mask and a horse's tail, which implies the existence of imitative magic and incantations. We see him leading terrified youths down into the cave in order to show them his work, which implies the existence of a system of initiation. It is impossible to say how much of all this is fiction. Most of these hypotheses are reasonable; each is based on physical evidence that may constitute proof. The picture as a whole is even unassailable in the sense that almost nothing has been added to it over the past half-century. The ethnography of prehistory has withdrawn from the field, at least temporarily, to rest upon its hard-won half-certainties.

This creation of a living, intelligible prehistoric mankind marks a crucial stage; today, however, we may raise one methodological objection. To take what is known about prehistory and cast about for parallels in the life of present-day peoples does not throw light on the behavior of prehistoric man. All that is proved in this way – and this is not to belittle its importance – is that the behavior ascribable to prehistoric man falls within the same general patterns as the behavior of recent man; in other words, prehistoric man's behavior was human in the present-day sense. There really are Paleolithic bison marked with wounds, as today there are dolls stuck with pins for magic purposes; but when we count up the images of bison, we find fewer than 15 percent marked with wounds or with weapons sticking in them. What, then, was the purpose of the remaining 85 percent? To be sure, there are three or four instances of geometric signs placed over animals, and these may represent snares, but there are also hundreds of signs which are not placed over animals: where then is the proof that the Magdalenians practiced sympathetic magic?… All our conjectures concerning the initiation of young hunters are based upon the existence of narrow heel prints near the modeled bison at Le Tuc d'Audoubert. The existence of initiation rites in the Paleolithic Age is by no means out of the question, but we do not appear to have found a really scientific means of proving it by the comparative method, at least not yet. All that the comparative method can do is to tell us that initiation rites exist among many peoples of the world today, and that consequently prehistoric man may also have had them; it cannot go further than that.

Through what means can we hope to grasp more than a shadow of the inner life of the Australian aborigines and the Eskimos, or, for that matter, of that of some witch still casting her spells deep in the European countryside? Can we perhaps try to question prehistoric man directly? It is hard for us to question the dead without putting our own answers in their mouths, except by using a procedure which makes a strict distinction between the historical evidence and our own explanatory hypotheses.

André Leroi-Gourhan
The Art of Prehistoric Man in Western Europe, trans. Norbert Guterman, 1968

The Upper Palaeolithic in western Europe: cultures, sites, dates.

Dates C_{14}	Industries	Stratigraphic reference sites	Main sites with cave or portable art
Before the present			
10,000	EPIPALAEOLITHIC		Le Mas-d'Azil
12,000		Laugerie-Basse	Gönnersdorf Teyjat Limeuil
14,000	MAGDALENIAN	La Madeleine	La Madeleine
16,000			Font-de-Gaume / Altamira / Les Trois-Frères Enlène / Isturitz
18,000		Solutré	Lascaux
20,000	SOLUTREAN	Laugerie-Haute	Le Roc-de-Sers
22,000			Kostenki Avdeevo
			Pech-Merle
24,000	GRAVETTIAN		Gargas
26,000		Abri Pataud	Lespugue
			Cosquer
28,000			Pair-non-Pair
30,000		La Ferrassie	Oreille d'Enfer
32,000	AURIGNACIAN		La Ferrassie / Chauvet / Cellier
34,000	CHATELPERRONIAN	Bos-del-Ser	Vogelherd
36,000			
38,000			

The Magdalenian flint knappers of Etiolles

Well-conducted excavations lead to in-depth knowledge, not only of the activities and gestures of the prehistoric craftsmen but also of their concepts. This work allows archaeologists to build up a picture of social phenomena that would otherwise be imperceptible, such as apprenticeship in the knapping of flakes and blades within communities from the excavated settlements.

Habitation floor at Etiolles.

A complex social organization?

The social status of working hard rocks is not very well understood in ethnology. It is well known that ethnologists have generally taken little interest in the technologies of the societies they studied, and even less in the sphere of stone-working, a complex and not very spectacular domain. At a pinch there are drawings or succinct descriptions of the most explicit tools (arrowheads, knives, awls…) but never any precise information on the manufacturing methods (and even less on the difficult knapping technique) nor on the social role of those who practised them…. As for the knapper's craft, it is assumed that it fitted into the classically 'simple' social model of the type of hunter-gatherer society in which the nuclear cell is the basic unit of production, an autonomous unit that comprises all the technical knowledge necessary for survival.

Prehistorians generally imagine how past societies managed their lithic resources and manufactured their implements of worked stone by making an implicit reference to these ideas. It is therefore not without a certain sense of astonishment that, following the first studies of flint exploitation at Etiolles, we discovered evidence of a technological, economic and social organization that is far more complex than was expected in such a context.

A rigorous model

If it is assumed that the family couple was capable of manufacturing all the tools each of them needed, then it is hard to conceive of a technique being so difficult that it required a very long initiation to master it. But each individual of both sexes had to learn,

during childhood and adolescence, all the techniques that would be useful during adulthood; and in a present-day nomadic society, there is virtually no place for a preferential investment in a particular technique. So the prehistoric family cell must have been in a position to knap stone and, if necessary, retouch the supports obtained. The study of dwelling unit U5 at Etiolles has provided the evidence of an extremely complex knapping technique, caused certainly by the nature of the local flint, which is found in the form of exceptionally large nodules. It is not rare to find blocks of 50 cm [about 19 inches] in length, sometimes far more, and the way they were exploited brings difficulties that simply cannot be compared with those that normally accompany Magdalenian blade manufacture on classic materials. And, in U5, the best cores, which are also the largest, have all been knapped 'by a master's hand' with a perfect knowledge of the mechanics at work, and an unfailing skill, even with the hundreds of blows being struck. Next to these, one finds more circumstantial flintworking, less difficult and less ambitious, which reveals by contrast the quality and care of the most elaborate knapping.

Finally, we should not have been astonished to discover, in the worked material, evidence of an initiation in this technique. Eleven knapping episodes showed the existence of a very gradual and doubtless quite long apprenticeship: from beginners, who can be identified as children being trained in the first rudiments of an extremely complex process of learning and expertise, to the most experienced apprentices (adolescents? young adults?) who already had access to decent materials, even if these had been put to use by the best experts.

Finally, the dwelling itself reflected quite clearly the way in which knapping activities were organized, which can be summarized as follows: 'anybody could not do anything anywhere'. The twenty-five examples of elaborate knapping were carried out either at the immediate periphery of the shelter's central hearth, or in exterior flintworking areas. Slightly set back from the hearth are located the more casual examples of knapping, carried out by flintworkers whose skill is difficult to appreciate, but who can be considered 'average'. Finally, on the outskirts, near the sleeping areas, and thus in what were normally the most private zones of the dwelling, there are the clumsy examples of knapping.

Thus, the studies of U5 at Etiolles showed that lithic resources were carefully managed and had unexpected social importance. It is not unreasonable to put forward the hypothesis that knapping involved specialization and a well-organized apprenticeship to teach technique. To explain a social organization of knapping, so different from what was understood of hunter-gatherers, it is possible to invoke the very exceptional nature of the local flint. Unique and precious, but also very difficult to exploit, it stimulated the Etiolles societies to adapt themselves to its demands and to put effort into teaching certain privileged knappers.

M. Olive, N. Pigeot
La Pierre préhistorique,
13–14 December 1990

Natural resources and nutrition

If one judged by the food remains found in sites, the prehistoric hunters would appear to be carnivores. In fact, as Gilles Delluc, a prehistorian and doctor, proves, their omnivorous diet varied, changing throughout prehistory with the climate and ecosystems.

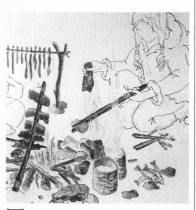

T he Palaeolithic site of Pincevent.

The daily life of a Cro-Magnon

It has been calculated that the daily work of the Cro-Magnons, involving the acquisition and manufacturing of tools and hunting weapons, could scarcely have taken a few hours per day. In the right season, a reindeer that had been killed without great difficulty in the heart of a large herd and brought back to camp could provide a nuclear family with enough nutrition for a week (flesh, fat, even plant foods as among those peoples who eat the stomach contents of these animals) and raw materials for making clothing, moccasins, straps, ropes, belts, weapons, various objects and jewelry. Among Bushmen the amount of work done in the week lasts twelve hours (two six-hour days). It is estimated that hunter-gatherers 'located in the environments which appear, if not the most hostile, then at least the most marginal in relation to world traffic and industrial networks' still need three to five hours per day to procure food…. Among food producers, including ourselves, in a very general sense, it is work (often performed outside the home)…and domestic jobs done at home…that have replaced hunting and fishing on the one hand, and foraging and gathering on the other….

Ethnologists estimate that such groups normally comprise between 200 and 500 people; below this number, it is difficult to find a spouse; above it, there are too many people for the hunting-and-gathering territory. On the basis of excavations involving one or several huts or tents, prehistorians prefer the notion of a nuclear family to that of a group – the family is ten times smaller, and corresponds to population densities that are far lower than one person per

square kilometre. Noting that a square kilometre can bear five reindeer, that ten reindeer feed a man for a year, that hunters have a radius of activity of twenty kilometres and that they kill one animal in ten, André Leroi-Gourhan concluded (though without taking fishing and gathering into account) that 1500 square kilometres [580 square miles] were required to feed about fifty people, and that this group had to have a 'tendency to break up into small communities of ten to fifteen individuals in order to exploit their hunting territory to the best advantage'. However, the rich and organized art of Lascaux, as well as the number of humans visiting the cave (more than a hundred lamps were found there), correspond to a big group, doubtless spanning one or several generations. As is well known, exogamy is the exchange of young genitors from one group to another: it is known among other primates. Such exchanges have enabled technological processes (methods of manufacture of tools and weapons of stone and bone), aesthetic tastes (jewelry), myths and artistic styles (cave and portable art), as well as certain materials (the various types of flint) and objects (shells) to spread gradually over enormous areas. They must have played a role in standardizing nutritional habits, which differed according to local resources, geography and climate.

Diet

These modern humans ate game and substantial quantities of plants, which provided at least as much energy in the diet as meat contributes, except in inhospitable regions (Beringia, Siberia, Alaska), where meat is more common. Then climatic factors and over-hunting reduced the animal resources.... Aquatic resources and wild cereals started being used, as revealed by analysis of strontium in bones, which marks the increase in plant foods and the decrease in meat consumption; radiocarbon measurements, among certain groups in Israel, also show the arrival of farmers on the scene more than 10,000 years ago. Agriculture appeared in the Near East, in China, in Central America and Peru; it spread in the course of the last ten millennia. Meat no longer represented more than ten per cent of calorie intake, and the number of available plant species diminished. The nutritional model did not change much until the Industrial Revolution, which brought meats rich in (saturated) fats, and fast sugars, but with a range of plant resources comparable to that of gatherers, though with fibreless foods. Risks of endemic infections and traumatic accidents were followed, in the Neolithic, by risks of famines and epidemic infections, not to mention wars. Today, life expectancy has risen sharply above the previously sustained level of thirty to forty years, thanks to the progress of hygiene and therapeutics.

Gilles Delluc with Brigitte Delluc and Martine Roques
La Nutrition préhistorique, 1995

The rise of art

Artistic creation is a recent phenomenon. It is the last great invention of prehistoric people that propelled them into modernity. As a neurologist, Roger Vigouroux breaks down the complex evolutionary and functional processes of the brain, in particular the frontal maturation that was finally attained by Homo sapiens sapiens, *who made the first images.*

Artisan, but not artist

Homo faber began to manufacture tools with an aesthetic sense, in this way responding to the need to harmonize the object they were shaping with internal cognitive structures that were already perfected. One day they reached the stage of symbolic and deductive thought. Incapable of understanding the world around them, anxious about their own destiny, they created the myth that they expressed through the medium of art. For this process to take place, their brain had to evolve and become bigger. Its volume, between 435 cc and 582 cc in the australopithecines, rose to 775 cc in *Homo habilis*, had exceeded 1000 cc in *Homo erectus*, and reached 1500 cc in the Neanderthals. The gradual development of the associative

Dancing in Tahiti.

areas led to an improvement in neuropsychological activities, which in turn helped to handle information from the outside world that reached any sensory channels – visual, auditory and tactile. All the nerve structures had evolved in this same direction. For example, the rhinencephalon, which in lower vertebrates played a prominent role in integrating olfactory data, had become one of the essential regulatory devices of the emotions. In *Homo sapiens sapiens*, the frontal lobe blossomed....

The rise of art in the history of humanity corresponds to the last evolutionary phase in the brain's development, that in which the neuropsychological activities of the frontal lobe became predominant. Yet one should not imagine that there is a cerebral 'Rubicon'. In fact, there is a long process of developm[ent] begins in the achievements of [the] biological animal mind, and bec[ame] more refined throughout evolutio[n]. The very first traces of an aesthetic sense can be found in the tools of *Homo erectus* and, later, in the few pieces of jewelry made by the Neanderthals and in the works of the Cro-Magnons, in which we recognize ourselves.

The brain, a tool for creating

Is it not true that every artistic creation contains evidence of the sequence of events involved in the evolution of species? Every work seems to have a meaning that is connected somewhere along the line with the productive activities of animal species or of the ancestors who preceded us on the road to hominization [or the process of

becoming human]. There seem to be four important steps.

The first stage is behavioural. The message expressed meets an organic need related to the vital functions of the individual and the species. It is above all a signal, a call, a means of communication. Sexuality and reproduction may be the driving forces behind this stage. They appeal to seduction, with the motivation to please. Social cohesion is also an objective. The calls of primates ensure group unity. The poetic songs and ritual dances of primitives express the aspirations of men and women as members of a community rather than as individuals....

The second stage relates to gesture. Primates play with chalk, pencil, brush, colours, and produce general shapes that testify to a certain sense of order. They aim to 'disrupt' the chaotic arrangement of physical reality, to mark the world with their imprints, in order to subdue it. For them, it is not a case of creating a durable work, of making an art object. What drives their spontaneous, unthinking, intuitive activity is a need for play, anchored in their nervous system. They create shapes that correspond to their internal system of representation. With the artisan and the artist, this set of gestures arises from the necessity to harmonize the object being shaped with the feelings experienced, to connect the hostile and rebellious material with our own internal cognitive structures, to establish a form of coordination, of *coherence between the physical world and our mental world*. It is possible that the aesthetic side of some handaxes made by *Homo erectus* originates in this mechanism.

The third stage assumes the appearance of rational thought. Confronted by the great mysteries of life, and anxiety about death, humans invent myth, for reassurance. They express it, quite naturally, in a work which *perpetuates their existence*, and places them in relation to the living forces of the universe.

Art, at last

The fourth stage belongs to *Homo sapiens sapiens* alone. Aesthetic feeling acquires an autonomous existence. It becomes mental representation, conscious thought. At this moment, art – which was at first associated with the sacred and with writing – breaks free from these ties and exists in its own right.

Above: a mask worn by the sorcerers of New Guinea. Opposite: Rodin in his studio.

This evolution has not ended. Although our brain is practically the same size as the Cro-Magnons', it is possible that its innermost organization, the fruit of all the adaptations to the outside world, is still subject to gradual modification. The perfection of language, the appearance of increasingly sophisticated techniques requiring new gestures, the evolution of emotional and social relationships, the appearance of new systems of communication, the computer and many other acquisitions gradually modify our ways of thinking and very probably intervene in the actions of our neuronal network. Our brain is not a closed, static system but, on the contrary, turns out to be remarkably plastic. This explains why the notion of art does not possess the same meaning in different periods, and why the message expressed varies in accordance with the socio-cultural context. The common denominator that enables a work – through its universal and permanent nature – to remain artistic is, as André Malraux might say, that sacred and divine something, that collective memory buried deep within ourselves, which links us to those humans whose roots can be traced back more than 30,000 years ago.

Roger Vigouroux
La Fabrique du Beau, 1992

Mythology and metaphysics

Although it remains difficult to speak of religion where Palaeolithic people are concerned, it is possible to make a comparative study of ritual practices, like this one by Jean-Pierre Mohen, based on the signs and evidence found in burials, of course, but also sometimes in caves and dwellings. The afterlife of prehistoric people then seems more accessible, and myths begin to emerge from the archaeological facts.

The theme of the dead hunter

Metaphysical expression is conveyed by depicting a wounded animal charging at a man, a single scene, and the result of this double assault, the death of the man and doubtless, very soon, the death of the bison. When we look at hunting peoples, Siberians or Eskimos, we can understand the anxiety of the archer or the harpoon thrower who, to feed his family, has to seek the mercy of the spirit of the forest, the bear-god, or the spirit of the icy sea, the whale-spirit. To kill in a world where life animates everything, even the invisible or the inanimate, is a serious fault that can only be eased by forgiveness.

The dead man in the Lascaux shaft [below] is in a cultural, not a natural, situation. His symbolic presence is made explicit by the baton decorated with a bird. The confrontation with the animal creates a double tension in which each of the actors is a bearer of both life and death: the disembowelled bison is losing its intestines and its blood; at the point of death, it has the strength to charge in a final moment of extra energy concentrated on the destruction of the man. The latter, outstretched and inert,

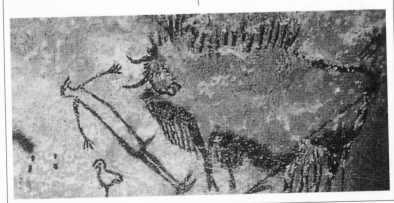

seems dead and in great danger; his decorated baton has fallen from his hands but it is understood that, whatever happens, the idea of the bird that adorns this baton will remain intact. The eternity of cultural life goes hand in hand with the eternity of physical life, expressed here in the most brutal fashion by the naked, killed man.… Lascaux's shaft scene plunges us into a mythical world which is also found in the burials from this period of the Upper Palaeolithic.…

The symbolic world of the grave

A few extraordinary examples show that this society went very far in the psychological exploration of human individuality. Let us take the example of the double burial at Palini, in Italy, which contains the skeleton of a young woman next to the skeleton of a dwarf. The myth of Quasimodo was lived out 20,000 years ago, and immortalized in the eternity of the tomb! Was either one of them sacrificed? This is a profound question: and for the moment it has no answer.

At Barma Grande in Italy, three corpses were buried simultaneously. An adult male stretched out on his back is the most richly adorned, with a cap decorated with seashells, fish vertebrae, stag canines and ivory pendants on his forehead, with a necklace of numerous beads, and with jewelry at his knees. A woman placed on her left side, with her arms folded across her chest, seems to cling to the man's shoulder, while an adolescent in the same position seems to cling to the woman in the same way. The woman does not have any necklace, jewelry at her knees, or stag canines at her forehead. What do these attitudes mean? Jealousy? Or what else? Why are the actors all fixed in these positions?…

The difference between the sexes is clear in Palaeolithic burials, but it is usually expressed discreetly; the presence of deer canines in masculine jewelry, as well as hunting weapons (spears and javelins), association of women and children in some rare cases. It is even astonishing that in the highly symbolic world of the grave there are so few female or animal statuettes, or any other manifestation of portable art for which André Leroi-Gourhan proposed a sexual interpretation, as he did for cave art. Two exceptions – the fragments of an ivory sculpture representing a man, found in burial II at Brno in Moravia, and a small bone horse from the burial site at Sungir in Russia – do not appear to have any particular significance. There remains the unique example of a burial at Mal'ta, in Siberia: beneath a small monument made of an accumulation of little slabs, a child dusted with ochre was adorned with a necklace of beads and pendants, including a sculpted bird in flight. At its belt hung a decorated plaque of mammoth ivory.

Death is integrated with life

It appears then that the funerary domain possesses a strong and varied expression, relatively independent of every other cultural manifestation. Death is integrated with life. At Le Mas-d'Azil in Ariège, a skull with its eyesockets encrusted with bone discs, isolated at the back of the cave, was venerated by the living. In the cave of Le Placard in Charente, and in the cave of Isturitz in Pyrénées-Atlantiques, marks observed on jaws and skull bones indicate that flesh was removed from dead bodies. Skullcaps were transformed, by polishing the edges, into small dishes, specific objects that have no equivalent

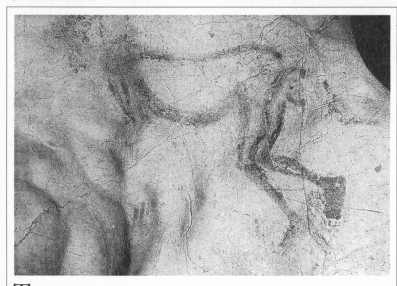

The 'sorcerer' or horned god from the cave of Les Trois-Frères in France. Previous page: the 'shaft scene' of Lascaux.

in animal skulls. Engravings on skull fragments reinforce the idea that the Magdalenians had a particular interest in manipulating and venerating human skulls in the second half of the Upper Palaeolithic. The sixty-year-old man discovered at Sungir, covered with ochre, was protected by a large boulder, on which was placed as an offering the skull of a woman.

Other kinds of funerary layout include the exceptional sites that involve animals. The site at Mal'ta in Siberia probably contains the burial of a blue fox, which would confirm the particular role played by this animal in the symbolism of the funerary adornments of prehistoric humans. This example might also ascribe to this animal a spiritual life similar to that of humans. The site of Amvrosievka in the Ukraine

recalls the sacrificed bison of Lascaux: it has an ossuary with nine hundred and fifty or a thousand bison that were killed on purpose and collected here. This charnel house also evokes the site of Solutré to the north of Mâcon, where thousands of horses were killed and cut up. Another, even more enigmatic case, which is quite similar to the bear 'sanctuary' of Régourdou in the Dordogne, is the site of Eliseevitchi in Russia. It takes the form of an enclosure made of mammoth skulls. A long buried corridor is edged with shoulder blades and pelvis bones of the same pachyderms. Among the remains found at this site, it is worth mentioning ivory plaques, decorated with engravings representing fish and geometric motifs.

To conclude this discussion of funerary rites at the time of Lascaux,

MANNEQUIN FUNÉRAIRE
VISAGE MODELÉ ... TÊTE OSSEUSE DÉFUNT
ÎLE MALLICOLO
DON ... M. FRANÇOIS N° 54220

we can call into question the notion of a 'primitive' prehistoric *Homo sapiens* who buried the dead in a stereotypical way, in accordance with an afterlife, a continuation of earthly life. In the face of death, Upper Palaeolithic humans behaved not only according to rites that were doubtless dictated by certain mythologies – of which the Lascaux shaft scene may be an illustration – but also according to rites adapted to the most varied situations. Their whole experience was dominated by a vitality that goes beyond death, and that animates the drawings of wounded men on the cave walls and the skeletons laid out in the graves.

It is in accordance with this principle of vitality that in Greenland, when people die, their name is given to a newborn child, so that the best of them should continue to live. The ease of the transfer is doubtless merely apparent, but there is a strong belief in a life that cannot put up with a cold, inert body, and that continues its destiny in another body.

Jean-Pierre Mohen
Les Rites de l'au-delà, 1995

Funerary mannequin from the Mallicolo Islands in the Pacific Ocean.

Cosquer Cave

*Since the discovery of
prehistoric art at this
underwater cave in 1991,
several expeditions have
taken place. Their main
objectives were to take
topographic readings,
complete the inventory
of the depictions and to
study the climate. However,
no specialist in Palaeolithic
cave art has yet been able
to examine the images on
the walls at first hand.
The full scientific study
of Cosquer Cave still has
to be undertaken.*

Hand stencils on a wall in Cosquer Cave.

Preface

In 1985 Henri Cosquer…a professional
deep-sea diver from Cassis, discovered
a narrow passage some 120 feet below
sea level at the foot of a cliff at Cape
Morgiou in south-eastern France. It was
not until July 1991, however, that he
came to notice prehistoric paintings and
engravings above the waterline in a large
chamber 490 feet beyond the entrance.

These paintings and engravings have
been preserved because the passageway
opening into the cave slopes upward and
the upper part of the walls has remained
above water. Twenty thousand years
ago, at the coldest point in the last glaci-
ation, the Mediterranean was about 360
feet lower than it is now and the shore-
line about 7 miles farther out. When the
ice melted, 9000 years later, the runoff
produced a spectacular rise in sea level.…

Precise dates were obtained for pieces
of charcoal lying on the cave floor and
for traces of charcoal lifted from draw-
ings on the walls. These dates can be
grouped into two series, one about
27,000 years BP (before the present)
and the other about 18,500 BP.…
This makes the Cosquer cave the most
extensively dated painted cave now
known. It was visited during two
periods only, with an interval of
8500 years separating them – a fact
that poses interesting questions.

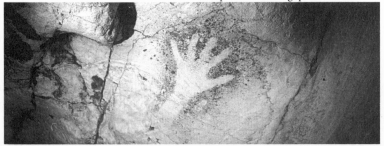

The rock art of the first period is characterised by stencils of hands with incomplete fingers, made by placing a hand against a wall, curving selected fingers, and then blowing paint around the hand to outline it in red or black against the blank wall surface. Also in that period, visitors to the Cosquer cave covered the walls and ceilings with finger tracings (grooves in soft surfaces made by human fingers).

The second period saw the realization of the animal paintings and engravings. At present, about one hundred pictures of animals have been recorded. Most of these are horses, ibex, chamois, bovids, and cervids. A feline head and several indeterminate animals complete the set of land fauna. One of the most unusual features of the Cosquer cave is that sea animals are depicted as well, with eight seals, three great auks, a fish, and perhaps several jellyfish. Associated with this bestiary are geometric signs such as rectangles, zigzags, and spearlike signs on the bodies of the animals.

Study of the stylistic techniques and the methods used to represent the animals permits comparisons with the art of other caves of that period. There are particular parallels with Ebbou in the Ardèche department of France and with Parpalló in the Spanish region of Valencia. This suggests that the people of that time had wide-ranging contacts.

Scientific study of the Cosquer cave is only in its early stages, but the cave must clearly be considered one of the major painted caves in Europe and one of the most distinctive. Given the underwater entry, the controversy that ensued when the discovery was announced, and the slowly revealed richness of the ancient images in their superb underground setting of sea-washed stalagmites, the study of this cave has been a real adventure – one replete with obstacles, discoveries, and joys....

The discovery

Narrow, low, and unremarkable, in that there are a number of similar openings at the base of this sheer wall, this particular hole caught the attention of Henri Cosquer and attracted him in some strange way. Little by little during the month of September 1985, he made his way along this seemingly endless dark passage with all the care his experience with the dangers of such diving had taught him. Having conquered the crawlway at the end of the entry passage and investigated the water-filled chambers with their petrified forests of stalagmites, he emerged finally into the main chamber, where no human had intruded in 18,000 years.

In October 1985, during these first visits, equipped with a single diving lamp, he noticed neither paintings nor engravings, awed and overcome as he was by the magnificence of the calcite draperies, by their sparkling colors, by the crystals of aragonite in fantastic shapes, and above all by the air of mystery emanating from this cathedral beneath the sea....

Caught up in work and travel, it was not until several years later, in the summer of 1991, that he returned to the exploration of 'his cave'. On July 9, 1991, he was stunned to notice a hand stenciled in red on a wall of the large chamber. Intrigued, he returned that summer with his friends.... Amazed and incredulous at first, they then discovered most of the painted and engraved animals....

Meaning

To interpret Paleolithic art without the support of the cultural context that

inspired it is an undertaking full of pitfalls. We do not know all the myths, beliefs, and social and religious rules from which these representations arose. To try to decipher the meaning in the absence of this fertile base, now forever lost, we must rely on empirical study of the works and on more or less logical theories derived from direct knowledge of this art and of the practices of modern hunter-gatherer groups in other parts of the world.

During Phase One…the Gravettians left their mark even in the farthest corners of the Cosquer cave. Whenever the surface of the walls and ceilings proved sufficiently soft, it was covered with innumerable finger tracings…. This is not art: there is no creation in these tracings, no transposition of the real or the imaginary. The intention of those who did them can only have been the appropriation of underground space, the intention to make the appropriate surfaces theirs in their entirety. The meaning of these tracings seems completely different in this case from that of the animal and human depictions or the signs. If the possibility of a communication system in some form exists for the signs, it does not exist for the tens of thousands of interlaced lines, except in the elementary form of one single idea – that humans had taken possession of the cave.

The hand stencils that accompany the finger tracings probably express the similar intention of appropriating underground space. The symbol of a hand, wherever it occurs, marks taking possession, if only at an extremely basic level. The hand expresses personality, the presence of an individual. It can simply mean, 'I was here,' like the modern graffiti that cover so many cave walls…. In the context of Paleolithic art, which specialists agree to consider religious-magical, these hand stencils are no doubt filled with the deepest significance, but they are fundamentally identical, an affirmation of power. In the Cosquer cave, they are the work of adults; no children's hands have been discovered….

The Cosquer cave's place in Paleolithic art

Within broad outlines, the Cosquer cave conforms to the common context of Franco-Cantabrian painted caves. Their conventions and techniques have become so familiar to us that from the outset specialists and the public at large were struck more by its unusual aspects than by the basic qualities that link this Provençal cave to the other Paleolithic caves. And yet in the Cosquer cave, as elsewhere, the themes consist of animals and signs, with perhaps the unobtrusive presence of a human in an ambiguous role. Among the animals at Cosquer, the horse predominates as it does in most caves. The majority of the fauna are large herbivores; after the horses, the caprids, bovids, and cervids are most numerous. Even the indeterminate, composite, and fantasy animals, few in number, are not exceptional since they occur in almost all the important caves. Here again, the unusual animals, several chamois, a feline and two megaloceros, are represented by only a few examples.

The methods of depiction are within the norms, whether for techniques of black outline painting and simple engraving or for conventions of representation. The bodies of the animals are always seen in profile. They appear to be suspended in midair with no base line depicted, outside any context – no landscape, no housing,

no scenes involving people and animals so familiar in later periods.... Even if the drawing is cursory at times, the animals are well proportioned and are for the most part quite recognizable. Finally, as was true for almost all the deep caves, the Cosquer cave was not used as a habitat, at least the painted chambers were not. It was indeed a sanctuary; that is, a place of importance with limited access where only certain people came, perhaps on special occasions, to take part in ceremonies....

Paleolithic finger tracings are much more widely distributed in space and time than hands. Nevertheless, it is not often that finger tracings cover such extensive surfaces, that they have been so systematically applied to all reachable walls and ceilings, and that they are also so well dated. Their location in the Cosquer cave provides confirmation that they are earlier than 27,000 BP and that their primary purpose was to occupy as much space as possible, in this way taking possession of the cave....

The circumstances of its discovery also place the Cosquer cave among a very small number of caves where the archaeological context fortunately escaped both human and natural destruction and came down to us intact. This is only true, of course, for the chambers above water. In those chambers the ground was protected right from the start but the calcite covering them prevented prehistoric footprints from being preserved. On the other hand, some flint blades, small hearths, charcoal smudges on the cave walls and concretions, and numerous pieces of scattered charcoal have been preserved. These traces tell us things. They have already been the object of studies, and other studies will follow. For now, they have allowed us to know how the prehistoric people who came to the cave provided light by building fires on the ground and burning torches, and what was used for the torches. They give us an idea of the landscape outside the cave and show us that the deep chambers were not inhabited and that human visits there were few and brief. Too often in the past, chance discoveries of painted caves resulted in the almost immediate destruction of such modest but eloquent vestiges through which we grasp the actions of Paleolithic people in the caves.

Finally, the Cosquer cave displays some truly unusual features, characteristics found nowhere else. First and most obvious, the feature that made it the subject of international journalistic attention, is its location. Until now, no painted cave has ever been found beneath the sea. Beyond anecdotal interest, this discovery makes real to us something known theoretically but difficult to take in accurately, the disappearance of all the prehistoric coastal sites over hundreds of square miles because of the rise in sea level since the end of the last glaciation. The Paleolithic landscape, including the shoreline, was vastly different from what it is today. These changes have allowed only a minute and biased sample of habitats and sanctuaries to survive, so that our knowledge includes enormous gaps and is no doubt marred by errors in judgment. From this point of view the Cosquer cave provides a salutary warning against blind confidence in the accepted theories. Furthermore, it may prompt new discoveries....

Jean Clottes and Jean Courtin
The Cave Beneath the Sea: Paleolithic Images at Cosquer,
trans. Marilyn Garner, 1996

Chauvet Cave

One or two Palaeolithic decorated caves have been discovered every year since the 1970s in areas of France and Spain where caves and prehistoric dwelling places abound. However, the wall paintings in Chauvet Cave are exceptional, in terms of their aesthetic quality, technique and age. The paintings – Aurignacian works – are the oldest examples of prehistoric art ever found.

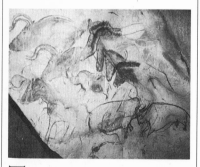

The Panel of the Horses in Chauvet Cave.

On the evening of 18 December 1994 we were the first three people for perhaps twenty thousand years to set foot in one of the world's most beautiful decorated caves: Chauvet Cave. Located in the side of a cliff in the gorges of the Ardèche in south-east France, it lies in the heart of a region that we have been exploring for many years....

We...explored all the accessible parts of Chauvet Cave, which extends for 500 metres (1700 feet) in a single level. It is decorated with magnificent crystallizations and concretions, white in the first chambers, then astonishingly and brilliantly coloured beyond. There is a succession of four chambers of impressive dimensions, in which there are numerous painted or engraved figures. Lateral galleries and vestibules are also decorated. The height of the ceilings varies between 15 metres (50 ft) and 30 metres (100 ft). The first two chambers are decorated with drawings done in red ochre; in the third, first there are engravings and then the black figures which cover the end of the cave.... It is a veritable museum. Wherever one looks, one is gripped by the beauty of the mineral forms or the drawn figures. Almost all the drawings are in a remarkable state of preservation. But the interest of this cave is not merely artistic; it is also an exceptional archaeological site....

In Chauvet Cave, most fortunately, everything remains to be done, everything is possible, thanks to the awareness and the intelligence of the explorers who picked up nothing and took pains not to damage the floors.... The cave's galleries were apparently not inhabited.... The usual refuse is nowhere to be seen....Very few traces in the cave are attributable to Palaeolithic people....

Torches were unquestionably used by the prehistoric visitors, or at least by some of them. In several parts of the cave, the walls bear characteristic traces of the wiping of torches, which happens when the torch is turning to charcoal and is revived by being rubbed downwards against the rock.... In at least one case, on the Panel of the Horses, the torch marks are later than the figures, since they are superimposed on the calcite that covers one animal's legs....

Some dates obtained...from tiny samples taken from three paintings done with charcoal (...two rhinoceroses...and the big bison...) proved to be far older than anticipated.... They were produced in the same period, within a timespan of 1300 years, centred on 31,000 years ago.

The samples from two different torch marks...indicate that the torch wipes occurred about 4000 years after the production of the paintings. The first of the two was superimposed on the calcite covering an animal on the panel of the facing rhinoceroses....

The dates show that the cave had several human incursions, separated by a few millennia. The first, about 31,000 years ago, was when some paintings were done.... More recent incursions occurred between 27,000 and 23,000 years ago, but we do not yet know if these latter visits involved the production of wall art or not....

These new dates overturn our conceptions not only concerning Chauvet Cave but also about the beginnings of art.... The dominant themes in Chauvet Cave, in particular the rhinoceroses and felines, can be explained more easily now that we know that some, if not all, belong to a very remote period: over the millennia, myths and concepts must have evolved, causing changes in the choices of animals depicted.... We now know that sophisticated techniques for wall art were invented by the Aurignacians at an early date. The rendering of perspective through various methods, the generalized use of shading, the outlining of animals, the reproduction of movement and reliefs, all date back more than 30,000 years.... Art did not have a linear evolution from clumsy and crude beginnings, as has been believed since the work of the abbé Henri Breuil.... From the start there were very great artists and accomplished productions in certain regions.... Our view of the beginnings of artistic creation and even of the psyche of these first modern humans has been changed by this....

The location of Chauvet Cave in the Ardèche changes our perspective on decorated caves. Until now, it was thought that there were major centres for cave art – the Périgord-Quercy region, the Pyrenees, the Cantabrian coast – and that the rest comprised minor groups.... With Chauvet, the Ardèche takes its place among the 'classics' of Palaeolithic wall art.... Chauvet Cave is very clearly one of the great sanctuaries of Palaeolithic art, comparable to Lascaux, Altamira, Les Trois-Frères or Niaux, but doubtless far more ancient. It has a decisive advantage over these caves, however, in that its floors are perfectly preserved and capable of yielding tremendous information about the human and animal activities which occurred in the cave.

Jean-Marie Chauvet, Eliette Brunel Deschamps and Christian Hillaire with an epilogue by Jean Clottes *Chauvet Cave: The Discovery of the World's Oldest Paintings*, trans. Paul G. Bahn, 1996

MUSEUMS

PRINCIPAL MUSEUMS OF EUROPE

AUSTRIA

Vienna Naturhistorisches Museum, Burgring. A very old institution giving a panorama of Austrian prehistory.

BELGIUM

Brussels Musées Royaux d'Art et d'Histoire. The museum contains important evidence of Palaeolithic humans from Belgian sites.

Brussels Musée/Institut Royal des Sciences Naturelles de Belgique. The museum has numerous collections from various Belgian sites.

BOSNIA-HERZEGOVINA

Sarajevo Museum of Bosnia-Herzegovina. Museum devoted to the prehistory of the region and neighbouring areas.

BULGARIA

Plovdiv National Bulgarian Museum. The museum brings together under one roof the Palaeolithic finds from Bulgaria.

CROATIA

Zagreb Croatian Museum of Natural History. The museum is devoted to the prehistory of the Croatian region and neighbouring areas.

CZECH REPUBLIC

Brno Moravian Museum – Anthropos Pavilion. The Anthropos Pavilion highlights the richness of the Moravian Upper Palaeolithic, notably the site of Dolní Věstonice.

Brno Moravian Museum – Dietrichstein Palace. Exhaustive panorama of the industries and faunas of the Moravian Palaeolithic.

Prague National Museum. The museum provides a general overview of the prehistory of the different territories of the Czech Republic and Slovakia.

DENMARK

Arhus Archaeology Museum. A museum in a park. It contains interesting scenes from prehistoric life.

ENGLAND

London British Museum. The museum houses the national collections of archaeology and art in Great Britain.

London Natural History Museum. It holds extensive collections of natural history, ranging from dinosaurs, mammals, primates, ecology and the earth and life galleries. Part of the collection is devoted to human evolution and the origin of species.

FRANCE

Bordeaux Musée d'Aquitaine. A very fine display of regional prehistory. It houses one masterpiece, the Venus of Laussel, known as the 'Venus with a horn'.

Les Eyzies-de-Tayac-Sireuil Musée National de Préhistoire. The museum provides a chronicle of the prehistoric cultures of south-west France, concentrating on industries, cave art, portable art and habitations.

Les Eyzies-de-Tayac-Sireuil Musée de l'Abri Pataud. An excavated site on display at the foot of the cliff, with the museum in a rock shelter. It complements the Musée National de Préhistoire at Les Eyzies-de-Tayac-Sireuil.

Nemours Musée de Préhistoire d'Ile-de-France. Dwellings from open-air Upper Palaeolithic sites in the Paris basin.

Orgnac-l'Aven Musée Régional de la Préhistoire. The museum provides a complete panorama of the prehistory of the Ardèche region. It concentrates on the spread of humans in the area.

Paris Musée de l'Homme. The largest French scientific institution contains thematic displays and a gallery devoted to human evolution.

Périgueux Musée du Périgord. The museum holds one of the most important prehistoric collections in France. It has exhibits on the burials at Chancelade and the Régourdou Neanderthal skeleton. In addition there are collections of flint and bone tools.

Saint-Germain-en-Laye Musée des Antiquités Nationales. A remarkable archaeological collection of French prehistory. The museum traces the history of France from prehistoric times to 800 AD.

Solutré Musée Départemental de Préhistoire.

Tautavel Musée de Préhistoire de Tautavel. The museum and site are entirely devoted to *Homo erectus*, following the way of life and the activities of these early humans.

GERMANY

Blaubeuren Urgeschichtliches Museum. The museum is close to the Ach caves and shelters, which were occupied by Stone Age people. As the caves were not touched by the ice sheets, many of the works of art were preserved. It contains a wide range of prehistoric material, including figurines carved from mammoth ivory that are over 30,000 years old.

Bonn Rheinisches Landesmuseum. The museum contains displays that are concerned with the Neanderthals.

Darmstadt Hessisches Landesmuseum. The museum houses collections of both art and natural history. There is a section devoted to the Palaeolithic of northern Germany and its industries.

Hanover Niedersächsisches Landesmuseum. The museum contains collections on the Lower and Middle Palaeolithic of northern Germany.

Mettmann Neanderthal Museum. Eponymous site of Neanderthal.

Munich Prähistorische Staatsammlung. A large museum devoted to regional prehistory.

Neuwied Museum für die Archäologie des Eiszeitalters.

Schleswig Schleswig-Holsteinisches Landesmuseum. The industries and remains from the site of hunters from the very end of the Palaeolithic.

GIBRALTAR

Gibraltar Gibraltar Museum. Display focused on prehistory, and on the history of research in the Gibraltar sites.

HUNGARY

Budapest Magyar Nemzeti Múzeum. The essential parts of the Hungarian Palaeolithic in an imposing setting. A vast display is devoted to prehistory.

ITALY

Florence Museo e Istituto Fiorentino di Preistoria. The museum provides a panorama of Florentine prehistory through its most prestigious sites.

Rome Museo Nazionale Preistorico e Etnografico. This large museum contains sections devoted to the Palaeolithic, which cover the whole of Italy.

MONACO

Monte Carlo Musée d'Anthropologie Préhistorique. A famous institution that houses the most prestigious remains of the Ligurian Upper Palaeolithic: the burials of the Grimaldi region.

NORWAY

Oslo National Historical Museum. Devoted especially, like other Scandinavian museums, to the recent prehistory of the Nordic peoples. However, there are also important collections on the cultures of Norway, as well as interesting ethnographic sections on the Arctic peoples, particularly the northernmost peoples of Europe (Greenland) and Siberia (Eskimos).

POLAND

Kraków Archaeological and Historical Museum. A large part of this museum is devoted to Ice Age prehistory. It contains very important collections.

PORTUGAL

Lisbon Museu Nacional de Arqueologia e Etnologia. The museum contains the major archaeological collections from Portugal. It includes the prehistory of Europe's western extremity.

ROMANIA

Bucharest Muzeul National de Istorie al Romaniei. The museum provides an overview of the rich Romanian Palaeolithic.

RUSSIA

Moscow History Museum. The museum exhibits the results of research into the major sites of the ex-Soviet Union.

St Petersburg Zoology Museum of the Academy of Sciences. An important display on the cultures and ways of life of prehistoric people in sites on the Russian Plain.

SPAIN

Ambrona Museo de las Excavaciones de Torralba. A small museum devoted to the famous open-air sites organized around elephant carcasses.

Madrid Museo Arqueológico Nacional. The museum house excellent displays on the general prehistory of the Iberian Peninsula.

Santillana del Mar Centro de Investigación y Museo de Altamira. This collection at Altamira provides useful information not only on cave art, but also on the prehistory of the north coast of Spain and, more specifically, of the Cantabria region. It is the first step to take before visiting all the other sites of the Basco-Catalan-Asturian regions.

Valencia Museo de Prehistoria y Servico de Investigación Prehistorica de la Exema Diputacion Provincial de Valencia. A good survey of the Palaeolithic sites of the region, especially the Spanish Mediterranean Upper Palaeolithic.

SWEDEN

Stockholm Nordiska Museet. The museum provides an introduction to the life of Swedish people. It contains a collection of recent prehistory.

SWITZERLAND

Neuchâtel Musée Cantonal d'Archéologie. The museum presents the Palaeolithic of the Alpine world.

UKRAINE

Kiev Museum of the Institute of Zoology of the Academy of Sciences. A gallery devoted to prehistory looks at the habitations of Transcarpathia and Ukraine (Mezhirich).

L'vov Institute of Social Sciences of the Academy of Sciences of Ukraine. The displays concentrate on a few important regional sites, including Molodova.

Museum list drawn from
Les Hauts Lieux de la Préhistoire en Europe,
edited by Jean-Philippe Rigaud and Jean-Michel Geneste, 1993

DECORATED CAVES
OF EUROPE

FRANCE

Bédeilhac-et-Aynat (Ariège) Cave of Bédeilhac.
A gigantic site with a wide variety of cave art:
paintings, engravings, models.

Cabrerets (Lot) Cave of Pech-Merle. The
richness of Quercy Palaeolithic art in a
remarkable composition.

Le Bugue (Dordogne) Cave of Bara-Bahau.
A cave with Palaeolithic engravings in an
original, even strange style.

Les Eyzies-de-Tayac-Sireuil (Dordogne)
Cave of Les Combarelles. A long corridor
entirely covered with fine superimposed
engravings which take some time to decipher.
Cave of Font-de-Gaume. One of the great sites
of cave art.
Abri du Poisson. A small shelter containing
just one engraving, but what an engraving!

Marquay (Dordogne) Shelter of Le Cap-Blanc.
Undoubtedly the most masterly lifesize
sculpted frieze of the Upper Palaeolithic.

Mas-d'Azil (Ariège) Cave of Le Mas-d'Azil.
A vast complex of sites from the end of the
Palaeolithic. Also the museum in the village.

Meyrals (Dordogne) Cave of Bernifal. A pleasant
walk in the Beune Valley leads to a remarkable
decorated cave with an engraved or painted
mammoth in every corner.

Montignac (Dordogne) Lascaux II and Le Thot.
A replica of the cave of Lascaux, whose quality
is not in doubt.

Niaux (Ariège) Cave of Niaux. One of the very
great Meccas of Pyrenean Palaeolithic art. For
reasons of conservation, the number of visitors
is strictly limited to twenty per group, and the
number of groups is small.

Payrignac (Lot) Cave of Cougnac. A decorated
cave at the border of the Lot and the Périgord,
remarkable for the quality of its paintings.

Prignac-et-Marcamps (Gironde) Cave of Pair-
non-Pair. The purest example of Aurignaco-
Perigordian art on the Atlantic front.

Rouffignac (Dordogne) Cave of Rouffignac.
The 'cave with a hundred mammoths' has
some exceptional parietal scenes.

**Saint-Martin-d'Arberoue (Pyrénées-
Atlantiques)** Cave of Isturitz and cave of
Oxocelhaya. Vast Upper Palaeolithic site, one

chamber of which is decorated with a sculpted
frieze made up of deer and horses.

Sergeac (Dordogne) Shelter of Castelmerle.
Set in a splendid setting, various Palaeolithic
sites in shelters. Several of them have produced
major works of portable art attributed to the
beginnings of Palaeolithic art.

Teyjat (Dordogne) Cave of La Mairie or Abri
Mège. Remarkable for the realistic portrayal
of animals in its Magdalenian engravings.

Valcabrère (Hautes-Pyrénées) Cave of Gargas.
A site famous for its numerous hand stencils.

Villars (Dordogne) Cave of Villars. A cave in the
northern Dordogne that is worth a visit.

PORTUGAL

Santiago do Escoural Cave of Escoural. One
of the few examples of cave art in Portugal, part
of an immense site.

SPAIN

Basondo Cave of Santimamiñe. A collection of
animal paintings from the Magdalenian period.
This archaeological site was frequently visited
from the Aurignacian on.

Medinacelli Los Casares. The most important
site for cave art outside the Cantabrian area.
Located near the palaeontological museum of
Ambrona.

Monte Castillo Caves of El Castillo and Las
Monedas. Only these two important sites can
be visited in the Monte Castillo; the others are
closed for conservation.

Primiango Cave of El Pindal, located in a cliff
overhanging the sea. It contains the famous
painted elephant.

Ramales la Victoria Cave of Covalanas.
Astonishingly spontaneous animal scenes that
characterize Cantabrian Palaeolithic art.

Ribadesella Tito Bustillo. Almost lifesize
polychrome reindeer, exceptional animals in
the Palaeolithic art of the Cantabrian region.

Ronda La Pileta. A major site for cave art in
a mountainous environment peculiar to the
south of Spain.

Santillana del Mar Cave of Altamira. The key
site for all of Cantabrian Palaeolithic art, often
compared with Lascaux.

List derived from *Les Hauts lieux de la Préhistoire
en Europe*, ed. Jean-Philippe Rigaud and Jean-
Michel Geneste, 1993

GLOSSARY

Acheulian Lower Palaeolithic culture, which takes its name from Saint-Acheul, Somme, France. The tools made by *Homo erectus* are mainly handaxes and cleavers. Divided into three phases, the Acheulian developed in Africa between more than a million years ago and 150,000 years ago. In Europe, central Asia and India it appeared around 700,000 years ago and disappeared into the Mousterian around 150,000 years ago.

angular Type of V-shaped sign in cave and portable art, with or without a bisecting central line (arrow). Frequent in the Magdalenian and in other prehistoric cultures.

arrow Hunting with a bow is frequently depicted in postglacial rock art. In Palaeolithic art, the word is used to designate angular signs with a long bisecting line.

Aurignacian Named after the site of Aurignac, Haute-Garonne, France, this is the first culture of *Homo sapiens sapiens* to spread through central and western Europe at the start of the pleniglacial period, between 40,000 and 25,000 years ago. It is characterized by the use of blade flint technology and bone tools. Portable art and art on blocks first appeared during this phase.

Azilian Culture of western Europe, named after Le Mas-d'Azil, Ariège, France, that followed the Magdalenian around 10,000 BP (Before Present). The start of the Azilian is marked by the climatic changes at the end of the last Ice Age. Its art takes the form of painted or engraved pebbles.

baguette demi-ronde Elongated semi-cylindrical object made of reindeer antler. Two baguettes demi-rondes stuck together could form a shaft for a spear. Western Middle Magdalenian.

baton *see* **perforated baton**

biface *see* **handaxe**

blade A narrow flake whose length is more than twice its width.

branching Type of sign in cave and portable art that evokes plant forms.

burin A stone tool, generally made of flint, that has a bevelled edge used to carve and engrave bone. Common in the Upper Palaeolithic.

Châtelperronian Culture named after the site of Châtelperron, Allier, France. The lithic industry produced by the Neanderthals preserved many features of the Mousterian culture from which it developed, but it also included Upper Palaeolithic flake tools. Around 38,000–32,000 years BP.

chequerboard Quadrangular sign containing a partitioned geometric structure, found in some Magdalenian caves, such as Lascaux.

chevrons Small angular signs painted or engraved in columns of two or more. Frequent in both cave and portable art in prehistory.

chopper *see* **worked pebble**

claviform A geometric club-shaped sign found in caves, mostly during the Magdalenian phase. Its name comes from the Latin, *clavus* for 'club'.

core A block of rock used to produce tools and weapons.

Cro-Magnons Direct ancestors of modern humans who appeared about 40,000 years ago. They bore a close resemblance to us, with the same high brow, prominent cheekbones and distinct chin. They developed the earliest European art during the Magdalenian period. Their name is taken from the Cro-Magnon rock shelter at Les Eyzies-de-Tayac in the Dordogne, France. Associated with the early Aurignacian.

dash A basic sign, painted or engraved, that comes in numerous combinations (lines, series). It is universally found on objects, and in shelters and caves.

dating There are several methods of absolute dating. Dating by analysing the carbon

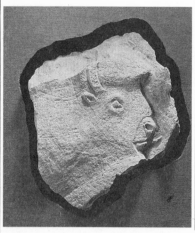

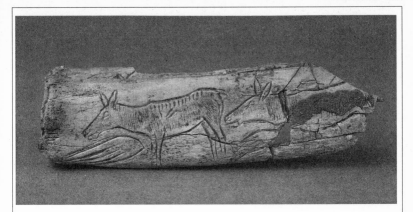

contained in charcoal or bone, C14. It covers the period of prehistoric art, that is back to about 40,000 years ago. The dates produced are given with a statistically calculated approximation in years either BC (Before Christ) or BP (Before Present, which has been fixed at 1950).

dot A basic sign, usually painted (rarely engraved), that comes in numerous combinations (lines, sheets). It is found throughout prehistoric shelters and caves.

endscraper A lithic flake or blade, somewhat thick, retouched at one end. A very common tool in the Upper Palaeolithic.

Epigravettian The name given to the culture which, in Italy, follows the Gravettian. In France and Spain, the Solutrean and Magdalenian were developing at this time (22,000–18,000 BP).

Epipalaeolithic The period and cultures of Europe that came immediately after the end of the Würm glaciation, and developed for two or three thousand years.

feathered signs Type of linear signs flanked by barbs, evoking feathers, and present in various areas of prehistoric art.

flake A fragment of rock struck from a core.

Gravettian Upper Palaeolithic culture that is named after the site of La Gravette, Dordogne, France. The lithic industry is especially characterized by the Gravette point, a narrow elongated blade, one edge of which has been transformed into a back through continuous retouch. This culture followed the Aurignacian and came before the Solutrean, between 28,000 and 22,000 BP.

handaxe A rather flat stone tool that has been completely worked and retouched on both faces. It is typical of industries of the Acheulian tradition and some Mousterian groups.

harpoon A hunting or fishing implement, carved in reindeer antler, that was invented by the Magdalenians.

Holocene or **Postglacial** Present geological period, which began around 10,000 years ago after the Pleistocene.

hominids An early form of human being in the family of primates. It is close to the family of the Pongids (chimpanzee, gorilla and orang-utan or great apes). At least 5 million years old.

hominization The process of becoming human, integrating cultural phenomena.

Homo erectus Human species found in Africa, Europe and Asia between 1.5 million and 300,000 years ago. Their cranial capacity was smaller than ours today, ranging from 775 to 1250 cc. These humans were the first to control fire and to build habitations.

Homo habilis The oldest human species yet to have been found. They were the creators of the first tools and lived between 2.5 million and 1 million years ago in eastern Africa. They had a cranial capacity of between 650 to 800 cc. Physically, they had a compact face and small teeth.

Homo sapiens These evolved representatives of the genus *Homo* appeared at least 100,000 years ago in Africa and the Near East. They spread around the world 40,000 years ago. *Homo sapiens neanderthalensis* is an archaic subspecies of *Homo sapiens* that took on individual

characteristics, in the Near East and Europe, before disappearing between 40,000 and 30,000 years ago. *See* **Neanderthals**

hyoid This little bone from the larynx, especially from the horse, was used as a favourite support for the Magdalenians' bone cutouts.

inlandsis Ice cap that covered the north of Europe, Asia, America and Greenland during the Pleistocene. Its extent changed with climatic variations.

laurel leaf Flat lozenge-shaped Solutrean point, completely retouched on both faces in a regular and precise fashion. A hunting weapon.

Levallois An Acheulian technique for obtaining flakes and points, which was invented by *Homo erectus*. It takes its name from the site of Levallois-Perret, Hauts-de-Seine, France.

limace ('slug') Mousterian type of double converging sidescraper on a thick flake.

Magdalenian The last major Upper Palaeolithic culture that spread throughout Europe between 18,000 and 10,000 years BP. It is characterized by a large diversity of tools and weapons made of stone and bone. The portable and cave art is exceptionally rich. It owes its name to the shelter of La Madeleine, Dordogne, France.

meanders Simple or multiple curvilinear lines made with fingers on the clay-covered walls of Palaeolithic caves.

Mesolithic A transitional period between the Epipalaeolithic and the Neolithic, covering several cultures in Europe.

microlith A very small stone tool. The tendency to diminish the size of these tools was particularly marked in Epipalaeolithic and Mesolithic cultures.

Mousterian A Middle Palaeolithic culture dating to 200,000 and 100,000 years ago associated with the Neanderthals. Its name comes from the rock shelter of Le Moustier, Dordogne, France. The lithic toolkits are very diversified. Burials indicate the metaphysical behaviour of *Homo sapiens* well before the appearance of graphic art.

Neanderthals This archaic form of *Homo sapiens* had an archaic physique (short, muscular and robust) with a sloping forehead, pronounced eyebrow ridges, projecting lower jaw and no chin. They appeared about 230,000 years ago in Europe and parts of Asia and disappeared between 40,000 and 35,000 years ago. They had a larger brain than the Cro-Magnons, with whom they lived for a short time.

Neolithic The cultural period that followed the Palaeolithic. During it humans took up a more settled way of life, growing crops, rearing animals, making pottery and polishing stone tools.

parietal Art – engravings, drawings or paintings – produced on the rocky walls of prehistoric caves.

perforated baton An instrument made of reindeer antler, perforated at one end and often decorated. It may have been used as a shaft straightener, and exists from the Aurignacian to the Magdalenian.

plaquettes A portable stone, which is usually flat, with engravings on it.

Pleistocene The longest geological period of the Quaternary, marked by major climatic contrasts, especially the advance of ice sheets. It began around 2 million years ago and lasted to 10,000 BP.

Pleniglacial A phase of intense cold in the last glaciation, from about 100,000 years ago, during which *Homo sapiens sapiens* developed in the northern hemisphere, especially in Eurasia.

portable art Art that appears on small objects, tools or weapons.

primates Order of mammals including the various families of monkeys, apes, hominids and humans.

quadrangular or **quadrilateral** Non-figurative, geometric structure with or without an infill or linear appendix, painted or engraved in Magdalenian caves.

Quaternary The most recent geological era, subdivided into two periods, the Pleistocene

and the Holocene. It began nearly two million years ago. Humans appeared during this period.

retouch The deliberate detachment of small flakes from a stone in order to make a tool.

shouldered point A finely retouched flint point, attached to the shaft of a projectile. A hunting and fishing weapon invented by the Solutreans, around 18,000 BP.

sidescraper A very common tool of the Mousterian culture, characterized by a thick edge, with scaly retouch, useful for scraping hides, wood or bone.

Solutrean Upper Palaeolithic culture that flourished in France and Spain. The leaf-shaped points of flint (laurel, willow) are remarkable. The sculpted art on blocks and bone needles first appeared during this period from 22,000 to 18,000 BP.

spatula A flat Palaeolithic bone tool whose outline was sometimes cut by the Magdalenians into the form of a fish.

spearpoint A point made of reindeer antler or bone, of various shapes, that forms part of the hunting weapons of the Upper Palaeolithic.

spearthrower An implement carved in reindeer antler by the Magdalenians around 15,000 years ago, but also known in other cultures, for example among the Inuit and Aborigines.

A kind of lever for the projection of hunting weapons.

stag canine A deer tooth used as part of jewelry from the Aurignacian on.

stratigraphy The study of the successive layers of sedimentary deposits in order to establish a relative chronology for the cultures represented.

Venus figurines Prehistoric statuettes of women, often with exaggerated features. They appeared during the Gravettian.

willow leaf Elongated, flat, lozenge-shaped Solutrean point, retouched on one face, in a regular and precise fashion. A hunting weapon.

worked pebble (chopper) A river pebble, with varying degrees of working to obtain cutting edges. Characteristic of the first human tool industries, pre-Acheulian, but also present in recent prehistoric industries.

Würm The last Quaternary glaciation in Europe, which ended around 10,000 BP. It was marked by alternate cold and temperate phases, with many short cold-warm oscillations within the main divisions. It ended around 10,000 BP.

Glossary derived from
Denis Vialou,
La Préhistoire, 1991

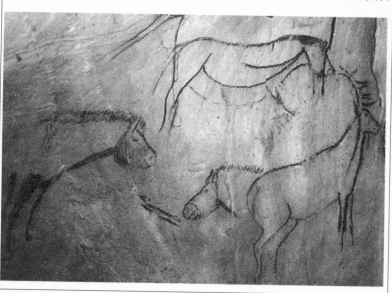

FURTHER READING

CAVE, PORTABLE AND ROCK ART IN PREHISTORY

Art des cavernes. Atlas des grottes ornées paléolithiques françaises, 1984

L'Art pariétal paléolithique, Groupe de Réflexion sur l'art pariétal paléolithique, 1993

Bahn, Paul G., *The Cambridge Illustrated History of Prehistoric Art*, 1998

—, and Jean Vertut, *Journey Through the Ice Age*, 1997

Bataille, Georges, *Prehistoric Painting: Lascaux, or the Birth of Art*, translated by Austryn Wainhouse, 1955

Berenguer, Magín, *Prehistoric Cave Art in Northern Spain and Asturias*, translated by Henry Hinds, 1994

Breuil, Henri, *Four Hundred Centuries of Cave Art*, 1952

—, and Hugo Obermaier, *The Cave of Altamira at Santillana del Mar, Spain*, translated by Mary E. Boyle, 1935

Chauvet, Jean-Marie, Eliette Brunel Deschamps, and Christian Hillaire, *Chauvet Cave: The Discovery of the World's Oldest Paintings*, 1995

Clottes, Jean, and Jean Courtin, *The Cave Beneath the Sea: Paleolithic Images at Cosquer*, 1994

Conkey, Margaret W., Soffer, Olga, Stratmann, Deborah, and Nina G. Jablonski (eds.), *Beyond Art: Pleistocene Image and Symbol*, 1997

Delluc, Brigitte, and Gilles Delluc, 'Lascaux II, a faithful copy,' *Antiquity* 58, 1984

Faustino de Carvalho, António, João Zilhão and Thierry Aubry, *Côa Valley, Rock Art and Prehistory*, 1996

Freeman, Leslie G. et al (eds.), *Altamira Revisited and Other Essays on Early Art*, 1987

Giedion, Siegfried, *The Eternal Present: The Beginnings of Art*, 1962

Graziosi, Paolo, *Palaeolithic Art*, 1960

Gvozdover, Mariana, *Art of the Mammoth Hunters: The Finds from Avdeevo*, 1995

Knecht, Heidi, Anne Pike-Tay and Randall White (eds.), *Before Lascaux: The Complex Record of the Early Upper Paleolithic*, 1993

Laming-Emperaire, Annette, *Lascaux: Paintings and Engravings*, translated by Eleanore Frances Armstrong, 1959

Leroi-Gourhan, André, *The Art of Prehistoric Man in Western Europe*, translated by Norbert Guterman, 1968

—, *The Dawn of European Art: An Introduction to Palaeolithic Cave Painting*, translated by Sara Champion, 1982

Lister, Adrian, and Paul G. Bahn, *Mammoths*, 1994

Marshack, Alexander, *The Roots of Civilization* (2nd ed.), 1991

Pfeiffer, John, *The Creative Explosion: An Inquiry into the Origins of Art and Religion*, 1982

Ruspoli, Mario, *The Cave of Lascaux: The Final Photographic Record*, 1987

Sieveking, Ann, *The Cave Artists*, 1979

Smith, Noel W., *An Analysis of Ice Age Art: Its Psychology and Belief System*, 1992

Ucko, Peter J., and Andrée Rosenfeld, *Palaeolithic Cave Art*, 1967

EURASIAN PREHISTORY

Barton, Nicholas, *Stone Age Britain*, 1997

Campbell, John, *The Upper Palaeolithic of Britain: A Study of Man and Nature in the Late Ice Age*, 2 vols., 1977

Clark, Grahame, *The Stone Age Hunters*, 1967

—, *World Prehistory* (3rd ed.), 1977

Gamble, Clive, *The Palaeolithic Settlement of Europe*, 1986

Klein, Richard G., *Man and Culture in the Late Pleistocene: A Case Study*, 1969

—, *Ice Age Hunters of the Ukraine*, 1973

Laville, Henri, Jean-Philippe Rigaud and James Sackett, *Rock Shelters of the Périgord: Geological Stratigraphy and Archaeological Succession*, 1980

Piggott, Stuart, Glyn Daniel and Charles McBurney (eds.), *France Before the Romans*, 1974

Smith, Christopher, *Late Stone Age Hunters of the British Isles*, 1992

Soffer, Olga, *The Upper Paleolithic of the Central Russian Plain*, 1985

— (ed.), *The Pleistocene Old World: Regional Perspectives*, 1987

Straus, Lawrence G., *Iberia Before the Iberians: The Stone Age Prehistory of Cantabrian Spain*, 1992

GENERAL PREHISTORY AND PALAEOANTHROPOLOGY

Burenhult, Göran (ed.), *The First Humans: Human Origins and History to 10,000 BC*, 1993

Fagan, Brian M., *The Journey from Eden: The Peopling of Our World*, 1990

— (ed.), *The Oxford Companion to Archaeology*, 1996

Falk, Dean, *Braindance: New Discoveries about Human Brain Evolution*, 1992

Gowlett, John, *Ascent to Civilization: The Archaeology of Early Humans* (2nd ed.), 1993

Johanson, Donald, and Blake Edgar, *From Lucy to Language*, 1996

—, Lenora Johanson and Blake Edgar, *Ancestors: In Search of Human Origins*, 1994

Jones, Steve, Robert Martin and David Pilbeam (eds.), *The Cambridge Encyclopedia of Human Evolution*, 1992

Klein, Richard G., *The Human Career: Human Biology and Cultural Origins*, 1989

Leakey, Richard E., *The Making of Mankind*, 1981

—, *The Origin of Humankind*, 1994

Mellars, Paul (ed.), *The Emergence of Modern Humans*, 1990

—, and Chris Stringer (eds.), *The Human Revolution: Behavioural and Biological Perspectives in the Origins of Modern Humans*, 1989

Nitecki, Matthew H., and Doris V. Nitecki (eds.), *The Evolution of Human Hunting*, 1987

— (eds.), *Origins of Anatomically Modern Humans*, 1994

Schick, Kathy D., and Nicholas Toth, *Making Silent Stones Speak: Human Evolution and the Dawn of Technology*, 1993

Stringer, Christopher, and Robin McKie, *African Exodus: The Origins of Modern Humanity*, 1996

Tattersall, Ian, *The Human Odyssey: Four Million Years of Human Evolution*, 1993

—, *The Fossil Trail: How We Know What We Think We Know about Human Evolution*, 1995

—, Eric Delson and John Van Couvering (eds.), *Encyclopedia of Human Evolution and Prehistory*, 1988

Thomas, Herbert, *The First Humans: The Search For our Origins*, translated by Paul G. Bahn, 1995

LIST OF ILLUSTRATIONS

The following abbreviations have been used:
a above; **b** below; **c** centre; **l** left; **r** right.

DOCUMENTS

INDEX

PHOTO CREDITS

Altitude 36. R. de Balbin Behrmann 90–1. Robert Begouën 96–7, 132. Bibliothèque Nationale de France, Paris 114. Casterman/J.-M. Labat archives 28a. Centre de recherche archéologique de Pincevent 21a, 124. CNRS/Pierre Bodu 19. Cosmos, Paris/B. and C. Alexander 29, 37. Cosmos, Paris/Pierre Boulat 53. Dagli Orti, Paris 72bl, 72br, 72l. Diaf, Paris/Jean-Daniel Sudres 58. Diatheo, Paris 15a. Eurelios, Paris/J. Clottes 138. Eurelios, Paris/Ph. Plailly 103a, 103c, 103b. Eurelios, Paris/O. Teixera 98. Explorer, Paris 82. Explorer, Paris/M. Cambazard 147. Explorer, Paris/J.-P. Ferrero back cover (left), 30–1. Explorer, Paris/Ferrero-Labat 102. Explorer, Paris/C. Michel 105ar, 105c. Gallimard archives 153, 154, 158. Gallimard/A. and D. Vialou 40a, 70, 70–1, 73b, 74, 75al, 75b, 83, 110–1. Gamma, Paris/J. Clottes 67. Gamma, Paris/H. Cosquer 134, 148. H. Hinz front cover, 1–9, 94b, 100. Hoa Qui, Paris/D. Reperant 46–7. Institut de paléontologie humaine (IPH)/A. Glory 34–5, 84–5, 88, 94a, 101b, 130. IPH/H. Breuil 51, 92–3. Institut für Urgeschichte, Tübingen 42, 42–3, 43. J. P. Kauffmann 18r. M. Lorblanchet 59b, 95b. Magnum, Paris/E. Lessing 64, 65, 66l, 66r. Ministère de la Culture/Eurelios, Paris/Jean Clottes 85. Ministère de la Culture/Gamma, Paris/Jean Clottes 89a. Musée de l'Homme, Paris 28b, 69, 86, 141. Musée de l'Homme, Paris/M. Delaplanche 62l. Musée de l'Homme, Paris/B. Hatala 17b, 18l, 52, 78l, 79. Musée de l'Homme, Paris/J. Oster 14al, 14ar, 25. Musée de l'Homme, Paris/J. Oster/D. Destable 78r. Musée du Solutré 35. Musée National de la Préhistoire, Les Eyzies-de-Tayac 17a, 55, 88–9, 95a. Musée National de la Préhistoire, Les Eyzies/J. Gaussen 48. Museum für die Archäologie des Eiszeitalters, Schloss Monrepos, Neuwied 21b, 50. National Geographic 45, 73a, 75ar. B. de Quiros 12, 56–7. Rapho, Paris 104, 105l, 113. Rapho, Paris/J. Dieuzaide 108–9. Réunion des Musées Nationaux, Paris spine, 13, 26, 27bc, 27r, 27al, 27ac, 32, 32–3, 48–9, 49l, 54a, 60–1, 61, 62r, 68–9, 76, 76–7, 77, 80l, 80r, 81, 87l, 87r, 144, 145, 146, 149. Roger-Viollet, Paris 117, 126–7, 128, 129, 133. Alain Roussot back cover (right), 47a, 87a. S.P.L. Cosmos, Paris/John Reader 40c. Y. Taborin 122. Gilles Tosello 22–3. Bernard Vandermeersch 44l, 68, 116. Tom Van Sant/Geosphere Project, Santa Monica/Science Photo Library/Cosmos, Paris 38–9. A. and D. Vialou 39, 54b, 56b, 63, 84, 89c, 90l, 91, 92, 93, 97, 98–9, 99a, 99b, 101a, 105b, 106, 107, 109, 112, 151.

TEXT CREDITS

Grateful acknowledgment is made for use of material from the following works: (pp. 138–9) Jean-Marie Chauvet, Eliette Brunel Deschamps and Christian Hillaire, with an epilogue by Jean Clottes, *Chauvet Cave: The Discovery of the World's Oldest Paintings*, translated by Paul G. Bahn, 1996; reproduced by permission of Harry N. Abrams, Inc., New York, Paul G. Bahn and Thames and Hudson Ltd, London. (pp. 134–7) Jean Clottes and Jean Courtin, *The Cave Beneath the Sea: Paleolithic Images at Cosquer*, translated by Marilyn Garner, Harry N. Abrams, Inc., 1996, English-language edition copyright © 1996 Harry N. Abrams, Inc.; reproduced by permission of Harry N. Abrams, Inc., New York. (inside front cover and pp. 118–20) André Leroi-Gourhan, *The Art of Prehistoric Man in Western Europe*, translated by Norbert Guterman, 1968; reproduced by permission of Harry N. Abrams, Inc., New York, and Thames and Hudson Ltd, London.

Denis Vialou,
doctor of literature and humanities, now devotes the greater part
of his research and teaching at the Muséum National d'Histoire
Naturelle in Paris to the prehistory of *Homo sapiens sapiens*,
including work on the Palaeolithic objects and
decorated caves of France and Spain.
He is currently in charge of excavating a Solutrean camp
in France and some rock shelters in the Mato Grosso
in Brazil, part of a project that is surveying shelters
with paintings and engravings.

Translated from the French by Paul G. Bahn

For Harry N. Abrams, Inc.
Eve Sinaiko, editorial

Library of Congress Cataloging-in-Publication Data

Vialou, Denis.
 [Au coeur de la préhistoire. English]
 Prehistoric art and civilization / Denis Vialou.
 p. cm. — (Discoveries)
 Includes bibliographical references and index.
 ISBN 0–8109–2849–3 (pbk.)
 1. Paleolithic period—Europe. 2. Art, Prehistoric—Europe.
 3. Europe—Antiquities. I. Title. II. Series. III. Series:
 Discoveries (New York, N.Y.)
 GN772.2.A1V5313 1998
 936—dc21

 98–22778

Printed and bound in Italy by Editoriale Libraria, Trieste